LEGEN

McLean

VIRGINIA

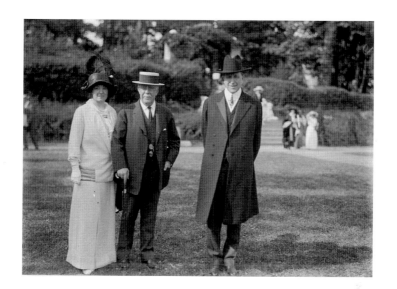

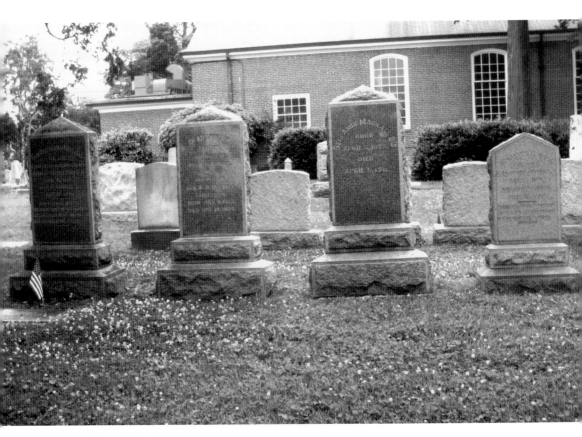

Mackall Family Tombstones
These two rows of tombstones in the Lewinsville Cemetery mark the graves of Mackall family members. The headstone on the far left identifies Confederate general William Whann Mackall (1817–1891). The fourth stone to the right belongs to Benjamin Mackall (1790–1880), the first Mackall to live at Langley. He was taken prisoner from his home by Federal troops during the Civil War. See pages 13, 95, and 96. (Carole Herrick.)

Page 1: John Roll McLean
John McLean is shown at right with Millicent and Randolph Hearst in 1913. (Library of Congress.)

LEGENDARY LOCALS

OF

McLEAN

VIRGINIA

CAROLE L. HERRICK

LEGENDARY
LOCALS

Legendary Locals is an imprint of Arcadia Publishing
Charleston, South Carolina

Printed in the United States of America

Library of Congress Control Number: 2014946261

For all general information, please contact Arcadia Publishing:
Telephone 843-853-2070
Fax 843-853-0044
E-mail sales@arcadiapublishing.com
For customer service and orders:
Toll-Free 1-888-313-2665

Visit us on the Internet at www.arcadiapublishing.com

Dedication
This book is dedicated to those invaluable individuals whose spirited dedication to their community has enriched the lives of those past and present.

On the Front Cover: Clockwise from top left:
Julia Knauss with children Julia, Annabelle, and Norman "Buddy" (Sylvia Knauss Sterling; see page 82), John R. McLean (Library of Congress; see pages 1, 2, and 28), Richard Mulvaney (March of Dimes; see page 74), John Wheat (William Wheat; see page 45), Bayard Evans (Caroline Evans Van Wagoner; see page 66), Henry Clinton Mackall (right) with brother Douglass and stepsister Julie Merrell Harris (Julie Merrell Harris; see page 95), Clive DuVal 2nd standing with Bob Andrews (DuVal family; see page 70), Mark Merrell, standing (Julie Merrell Harris; see page 68), President John F. Kennedy and Attorney General Robert Kennedy (John F. Kennedy Presidential Library and Museum; see pages 57 and 86).

On the Back Cover: From left to right:
Pat Strawser (Elaine Strawser Cherry; see page 39), Bill Elvin (Carole Herrick; see page 79).

CONTENTS

ACKNOWLEDGMENTS

The task of tracking down photographs of individuals significant to the history of McLean was a task far more challenging than I envisioned. However, the project was brightened by my acquiring an entirely new array of friends who enthusiastically met the challenge by digging through family albums or contacting family members. This book would have been impossible without their help. Their generosity and assistance proved invaluable. I can honestly say that the time spent on this project was a pleasure, and one of the joys of finishing this book is the opportunity to thank them for helping me through this project. I would like to give a very special thanks of appreciation to the following: Sabrina Anwah, Janet Beall, Don Beyer, Rosetta "Rosie" Brooks, Don Burns, Wanda Collins, John Dickerson, Sue Dorsey, the DuVal family, Nancy Falck, Peggy Fox, Jan Elvin, John T. Griffith, Don Hakenson, Mary Anne Hampton, Sonja Duffin Hurlbutt, William "Kip" Laughlin, Barney Lawless III, Suzanne Levy, Douglass Sorrel Mackall III, Roland McElroy, Julie Merrell Harris, Steve McAfee, Elaine McHale, Bill Millhouser, Ann Hennings, Merrily Pierce, Virginia McGavin Rita, Palmer Robeson, Page Shelp, Joan Smith, Zoe Sollenberger, the Stalcup family, Robert Stoy, Barrett Swink, Joan Crosby Tibbetts, Libby Trammel, Anne Morton Vandemark, Dariel Knauss Van Wagoner, Caroline Evans Van Wagoner, Mike Wheat, Laura Wickstead, and N. Lou Wissler.

I also wish to thank the following institutions: Alexandria Library, Special Collections Branch, Chain Bridge Bank, Dolley Madison Library, Fairfax County Park Authority, Fairfax County Police Historical Association, Fairfax County Public Library Virginia Room, Frying Pan Park, Historical Society of Fairfax County, George Mason University, John F. Kennedy Presidential Library and Museum, Lewinsville Presbyterian Church, Library of Congress, McLean Baptist Church, McLean Community Center, McLean Historical Society, McLean Project for the Arts, McLean Volunteer Fire Department, Pleasant Grove Church, and the Virginia Historical Society.

INTRODUCTION

This book is a history of McLean, Virginia, as seen through the lives of a few individuals that helped to make, or continue to make, McLean a vibrant place to live. However, it is a community without a central core, such as a town hall, village square, or even a historic district. McLean simply developed sporadically around a stop of the Great Falls & Old Dominion Railroad (GF&OD), an electrified trolley that ran from Rosslyn to Great Falls Park. There was no plan for the village's growth. From its inception, McLean was a spirited community where everyone got to know each other through civic and community involvement that enriched the lives of residents through socialization and fun. The thread that held the community together was a spirited volunteerism. Community activities were conducted mainly by volunteers. In the beginning, the events centered on the Franklin Sherman School, the McLean Volunteer Fire Department, Storm's Store, and the various churches.

McLean began in 1902, when John R. McLean and Sen. Stephen Elkins of West Virginia obtained a charter to operate the GF&OD. This was simply a business venture to promote the scenic beauty of the Great Falls of the Potomac River. The 14-mile line ran between Rosslyn and Great Falls Park and linked with Washington, DC, via the old Aqueduct Bridge. Its rails were laid through forests, farmland, and fruit orchards, bypassing the existing villages of Lewinsville and Langley. The trolley began operating on July 3, 1906, with a trial run to Great Falls Park. Its first scheduled passenger trip was the following day, July 4, 1906.

One of the stops was at Chain Bridge Road, which has been a major transportation artery through Fairfax County since Colonial times. At first, this stop was called Ingleside, after a subdivision that was beginning to develop along Elm Street and Poplar Street (now Beverly Road). However, a hub of activity quickly began to form at that location, and by 1910 residents began calling the Ingleside stop "McLean" in honor of one of the trolley's founders, who was also the publisher of the *Washington Post* and *Cincinnati Enquirer*. Therefore, the next stop on the line to the west became known as Ingleside. In June of 1910, Henry Alonzo Storm took over the operations of a general store that was located at Chain Bridge Road between the tracks and Elm Street, which included the McLean Post Office. In 1911, the Chesterbrook, Lewinsville, and Langley Post Offices were abolished and folded into the existing McLean Post Office. There was no depot. People either purchased their tickets at Storm's Store or from a conductor on the train. The day that Storm opened his general store is considered to be the beginning of McLean. There was no celebration. The "town" was not founded and was never incorporated. It is doubtful that John McLean ever set foot on turf at the stop named after him.

The Great Falls & Old Dominion Railroad significantly affected the Northern Virginia countryside, providing easier transportation to and from the District of Columbia. Farmers found it less difficult to get their crops and dairy products to market. Many businessmen discovered the art of commuting and sought permanent or summer homes for their families in the countryside. Settlements such as Franklin Park and El Nido developed at stops along the route, but the area surrounding the McLean stop underwent the most change; residents, organizations, and businesses wanted to be at that location. An amorphous, village-like settlement began to spread out from the stop in a hodgepodge fashion. For instance, St. John's Episcopal Church, built in 1877 just east of the Langley Fork, was mounted on casters and hauled across fields to a site on Chain Bridge Road, not far from the McLean stop. The Franklin Sherman School, Fairfax County's first consolidated public school, opened in 1914 with 29 students, fronting on what was later named Corner Lane. Initial meetings began in 1916 concerning what would ultimately become the McLean Volunteer Fire Department. The department incorporated in 1923 as Station No. 1 in Fairfax County; a two-bay station was built that same year on Chain Bridge Road a block south of the stop. Members of Sharon Lodge 327 built Sharon Masonic Temple at Emerson

Avenue and Chain Bridge Road in 1921, and the congregation of the McLean Baptist Church erected its first church in 1923 on Emerson Avenue on property adjacent to the lodge. Before long, there was a civic association, library, and several churches.

By the early 1930s, ridership on the trolley began to decline. The railroad was forced into receivership, and the route was abandoned on June 8, 1934. Its tracks were removed. This did not affect McLean. The automobile was now the preferred mode of travel, and the rail bed was turned into Old Dominion Drive. Farmers had become "truck farmers," taking their produce and milk products to District markets. McLean remained a rural agricultural community. After World War II, many who came to Washington, DC, to support the war effort decided to stay. Combined with the CIA locating to Langley in 1961, a steady increase in population began, and McLean found itself in the midst of phenomenal growth. The farms disappeared, initially replaced with split-level brick subdivisions and, later, grand homes. Still, there was no plan. McLean never became a separate town or city. It lost any opportunity to incorporate when, in 1968, Fairfax County adopted an urban county form of government. McLean remained a community, but without the central core that began with the trolley stop at Chain Bridge Road.

The unique character of McLean has attracted people from all walks of life. Government officials, ambassadors, corporate leaders, teachers, and artists weave a rich tapestry known as the McLean community. At "the center of it all" is the McLean Community Center, which opened in 1975. It replaced the firehouse as the area's hub and became the thread that holds McLean together. Not only does the McLean Community Center house the Alden Theater, but it provides meeting space for special programs, public forums, and monthly meetings of clubs and organizations, and it hosts special events, including McLean Day and the Fourth of July. The impact of individuals maintaining McLean as an excellent community is impressive. It is unfortunate that, with so many interesting and active citizens, this book can only highlight a handful.

CHAPTER ONE

The Early Years

Before 1910

McLean can trace its heritage to the land grants of Thomas Lee in 1719 and George Turberville in 1724. Much of today's McLean has developed on these two tracts of land. Eventually, two villages, Langley and Lewinsville, formed along the road that connected Fairfax Courthouse with a bridge at the Little Falls of the Potomac River. Today, that road is known as Chain Bridge Road. The bridge, built in 1797, was the first bridge to span the Potomac River. It has been called the Chain Bridge, after the third span, a suspension bridge supported by chains built in 1808. At Langley, the road joined a thoroughfare that led in the direction of Leesburg, forming a "fork." The village of Langley grew around this intersection. Lewinsville began at the crossroads of Chain Bridge Road and the road that led east to Falls Church and northwest toward the Great Falls of the Potomac. Both of these villages were farming communities. Farmers who took their fruit, vegetables, or milk products into the District generally went over the Chain Bridge. Both villages were large enough that they had their own post office by the outbreak of the Civil War.

Langley was occupied from October 10, 1861, to March 10, 1862, by Federal troops from two divisions of McClellan's Army of the Potomac: the Pennsylvania Reserves, commanded by General George McCall, and the Second Division, commanded by General William Farrar "Baldy" Smith. Federal troops garrisoned Lewinsville. Those supporting the Southern cause fled the area. After the Army vacated for the Peninsula campaign, Union troops continued to guard the Chain Bridge and Lewinsville.

Most of the farms were in shambles when the war ended. Not only did everyone have to deal with getting their farms back in good working order, but they had to learn to live with each other. A third community, Lincolnville, developed along Kirby Road. Its name was changed to Chesterbrook around 1900. Another community, Odrick's Corner, formed along Lewinsville Road. By the time McLean came about in 1910, the wartime animosities had subsided, and the farms were flourishing. The area was ready to accept the changes that the new community of McLean would bring.

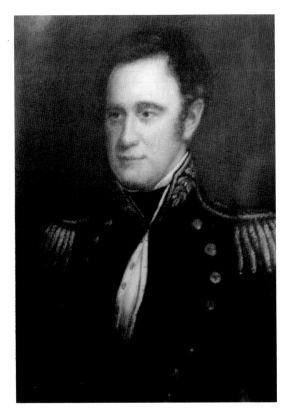

Commodore Thomas AP Catesby Jones

In 1805, at age 15, Jones joined the United States Navy as a midshipman. He spent time in the Gulf of Mexico in command of gunboats chasing pirates and blockade runners. In 1814, as a lieutenant, Jones was at Lake Borgne in command of a fleet of five gunboats that held three or four guns each when the British began their attack on the city of New Orleans. The British sent 42 longboats across the lake, each equipped with heavy artillery and 20 armed sailors. On December 14, 1814, the boats reached Jones's small force, which was blocking their path at Malheureux Island. The British attacked, but it was not until the third wave that the American force was overrun, with 41 Americans and 94 British either killed or wounded. Jones received a ball (never removed) in his left shoulder and taken to Bermuda as a prisoner. The Americans suffered a defeat, but it is thought that the action of Jones, who could have retreated before the enemy fired, delayed their approach to New Orleans by at least two weeks, giving General Andrew Jackson more time to organize defenses for the city.

Jones later inherited 140 acres of land in Fairfax County from his mother, Lettice Corbin Turberville Jones. He returned to Virginia and built a house facing the Georgetown-Leesburg Turnpike that he named Sharon. From there, Jones commuted to the Navy Yard, where he was the superintendent of ordnance. He married Mary Walker Carter on July 1, 1823, at the nearby Salona plantation. Mary was the daughter of Anne Beale Carter and stepdaughter of the Reverend William Maffitt, Salona's owner. Jones was a religious man. In 1846, he founded the Lewinsville Presbyterian Church on land donated by his aunt Martha Corbin Turberville Ball and was the first trustee. However, he was controversial. On October 20, 1842, as commander of the Pacific Squadron, he thought war with Mexico was imminent and captured Monterey, the capital of California. He realized his mistake the following day and promptly left Monterey Harbor. Jones was court-martialed in 1850 for his excessive use of flogging and other charges. The sentence was later dismissed, and Jones was restored to service in 1852 by President Millard Fillmore. Jones died at Sharon in 1858 and is buried in the Lewinsville Cemetery. (Fairfax County Public Library Archival Division.)

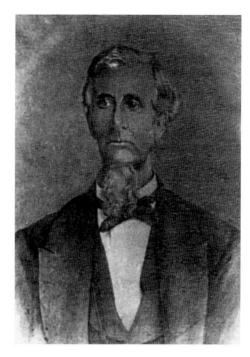

Jacob Smoot
Smoot purchased the 208-acre Salona tract in 1853. He farmed the land and raised registered Aberdeen Angus cattle. Having Southern convictions, he vacated his property and escaped to Georgetown when Federal troops arrived in 1861. General William Smith used the house for his headquarters, and the Vermont Brigade encamped on the surrounding grounds. After the war, Smoot returned, restored his property, and continued farming. (Smoot family.)

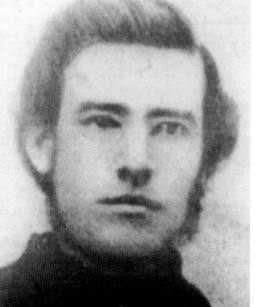

Captain Franklin Sherman
Sherman served with the 10th Volunteer Michigan Cavalry during the Civil War. After the war, he married Caroline Alvord and farmed Ash Grove, a 242-acre estate that his father, James, purchased in 1851. Sherman was the sheriff for Fairfax County and a member of Fairfax County's board of supervisors and the county's school board. The Franklin Sherman School is named for him. (Ancestry.com.)

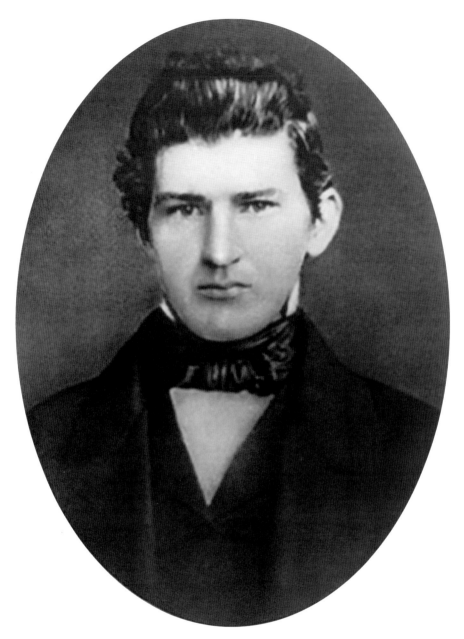

James W. Jackson

Jackson was born in a farmhouse on Georgetown Pike known today as the Dower House. He was an ardent Southern sympathizer. As the proprietor of the Marshall Hotel in Alexandria, he flew a large Confederate flag above its roof. When Federal troops entered Alexandria on the morning of May 24, 1861, Col. Elmer Elsworth, commanding the New York Zouvaves, removed the flag. Jackson shot and killed him. Union corporal Francis Bromly immediately shot Jackson. Elsworth was the first Federal officer to be killed in the Civil War, and Jackson was the first civilian casualty. Jackson's body was buried (though hidden) on the Georgetown Pike property but was later removed to the family cemetery at the Jackson estate on Swink's Mill Road. In the early 1920s, the Daughters of the Confederacy reinterred Jackson's body in the Fairfax Cemetery. (Alexandria Library, Special Collections Branch.)

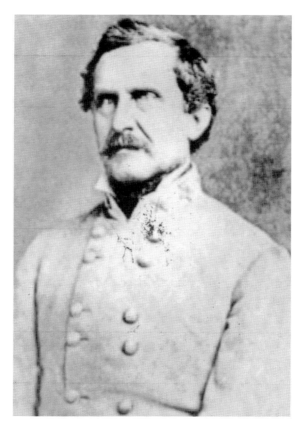

General William Whann Mackall

Mackall led a colorful life. He graduated from the US Military Academy in 1837 and was commissioned an officer in the 1st US Artillery. He was severely wounded during the Seminole Wars at River Inlet, Florida, and was again wounded during the Mexican-American War at the Battle of Chapultepec. At the start of the Civil War, Mackall was appointed a lieutenant colonel in the Confederate army, serving on the staff of General Albert Sidney Johnston. Mackall was promoted to brigadier general in April 1862. Immediately thereafter, while in command of the Confederate defenses at Madrid Bend and Island Number Ten on the Mississippi River, he was captured by Union troops. His imprisonment did not last long; he was exchanged on August 15, 1862. Mackall continued serving the Confederacy and, in 1864, became chief of staff to Johnston serving in the campaign against General William Tecumseh Sherman's march from Dalton to Atlanta. The overly cautious Johnston was removed from command and replaced with General John Hood as Sherman neared Atlanta. At his request, Mackall was relieved from staff duties, but continued to participate in Confederate operations until the surrender of Lee's army at Appomattox Court House on April 9, 1865. Later, he joined with Generals Howell Cobb and Gustavus Woodson Smith on April 20, 1865, and surrendered to Union forces at Macon, Georgia.

Before the war, William's father, Benjamin Mackall, lived at Langley and had voted for the Ordinance of Secession. Unlike many who continued to be loyal to the Southern cause and fled the area with the approach of the Federal army, Benjamin remained on his premises at Langley. He was arrested and taken to the Capitol Prison in the District of Columbia. His confinement did not last long, but he was not allowed to return to Virginia; it was thought that he would forward information about Union activities in the Langley area to his son. Thus, Benjamin spent the remainder of the war living in Georgetown. After the war, both men returned to Langley. General Mackall married Aminta Sorrell of Savannah, Georgia, and began a new life as a land speculator and farmer. He died in 1891 and is buried in the Lewinsville Cemetery. (John T. Griffith.)

Captain James Wallace Cooke

In 1828, Cooke, a North Carolina resident, entered the US Navy. His tours of duty were at sea until he was assigned to the Naval Observatory in Washington in 1853. Seeking a residence for his family, he purchased two separate properties at Langley totaling 103 acres and farmed the land. War became increasingly imminent. Cooke resigned his naval commission in June 1861 to join the Confederate navy. He left Langley, never to return. During the winter of 1861–1862, his house was occupied by Federal troops, who vandalized it and destroyed the farm. His property was later turned into Camp Wadsworth, a contraband camp. Cooke was wounded and taken prisoner during action near Roanoke Island. After being paroled, he oversaw the construction of the ironclad ram CSS *Albemarle* and successfully engaged Federal forces. (North Carolina Museum of History.)

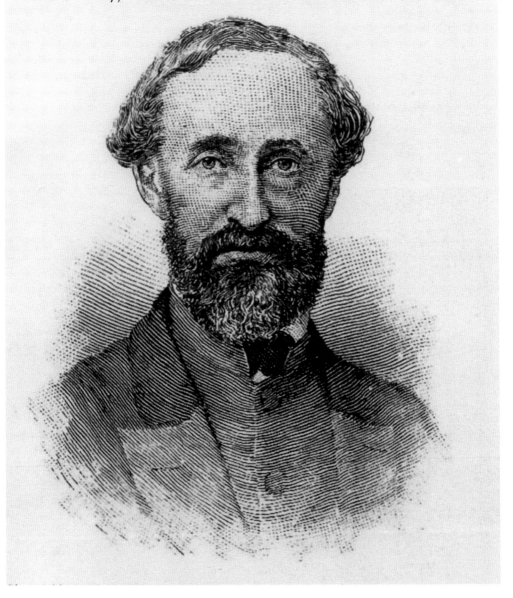

William Selwyn Ball
Ball was 15 when the Civil War began. His family left their Woodberry estate when Federal troops arrived in 1861. Their property, including the main house, Elmwood, was completely destroyed. A fort/signal station was erected on 10 acres where other buildings once stood. After returning, William built a log cabin he named Bachelor's Hall before building a second Elmwood in 1905. (Historical Society of Fairfax County.)

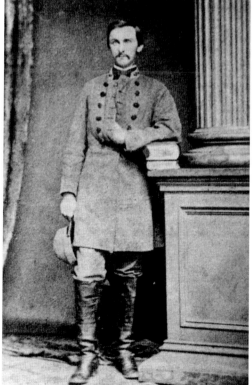

Mottrom Dulaney Ball
Mottrom Ball was born in 1835 at Elmwood, the main house on the Ball family's Woodberry estate. Before the Civil War, he organized a cavalry company, but he was captured on May 24, 1961, as Federal troops occupied Alexandria. When released, Ball joined the Confederate army. Finding the Woodberry property in ruins after the war, he relocated elsewhere in Fairfax County and opened a law practice. (Virginia Historical Society.)

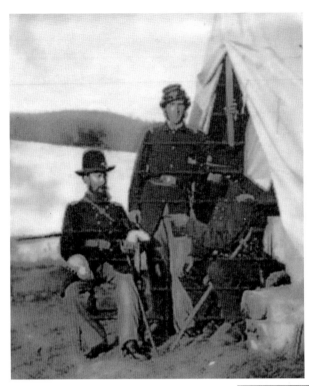

General John S. Crocker
During the Civil War, Colonel Crocker (later promoted to general) organized the 93rd New York Volunteer Infantry, Morgan Rifles. In 1869, he was appointed warden of the District of Columbia jail. During this time, he purchased small parcels of land in Fairfax County and sold them to black families. Crocker (left) is shown at Antietam with Col. Benjamin Butler (right) and an adjutant of the 93rd. (Library of Congress.)

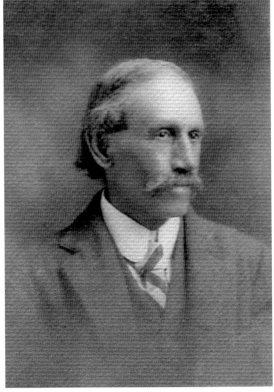

John Watson Mills
Mills was born of Indian descent (Pamunkey) in King William County in 1847. He came to Fairfax County in the early 1870s and married Martha Loretta Goings the following year. They lived in a log cabin off Spring Hill Road, where they raised four children. Mills, a farmer who also had skills as a carpenter, helped build Pleasant Grove Church. (Pleasant Grove Church.)

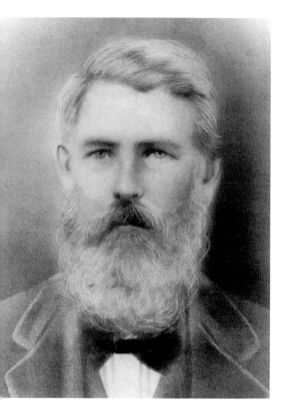
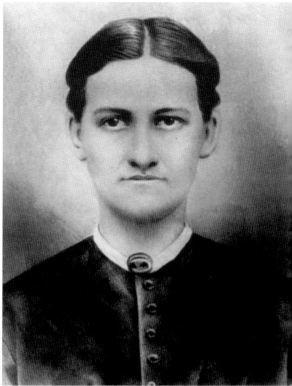

James and Sarah Adams Wren Hall
James Nathaniel Hall was born in Prince William County in 1843. Reportedly, he was a courier to General Robert E. Lee's staff during the Civil War. After the war, he moved to Fairfax County and, in 1868, married Sarah Adams Wren. They lived in Lincolnville, an area now called Chesterbrook. Sarah was the granddaughter of Susannah Adams whose first marriage was to Lewis Hipkins, owner of a tavern and mill near the Little Falls Bridge (renamed Chain Bridge). Lewis died from rabies. Susannah then married a lawyer named Richard Wren. In 1872, Sarah's parents, Thomas and Julia Wren, granted 49 acres of their property to their daughter. The property ran along Linway Terrace to Pimmit Run. James Hall farmed the land and took produce to the District markets by horse and wagon. (Both, Edward Smith.)

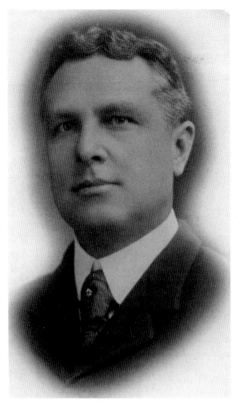

Douglass Sorrel Mackall

Mackall acquired the Langley Methodist Church property around 1900 and converted it into a residence. He oversaw farming operations, but was also a practicing attorney whose office was in the District. Mackall also speculated in real estate. Along with his brothers, Mackall formed the Langley Land Company and developed the Ingleside community near the trolley stop. Under a different company name, he later helped form West McLean. (Douglass Sorrel Mackall III.)

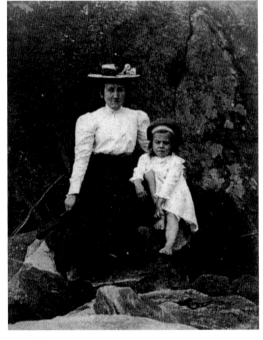

Lucy Chichester MacKall

Lucy Chichester grew up in Fairfax County at Mantua. In 1893, in a double ceremony in which her sister Sallie married Samuel Loving, Lucy married Douglass Sorrel Mackall. The Mackalls lived in Langley, where they raised one daughter and four sons: Lucy Douglass "Dottie" Mackall, John Chichester Mackall, Douglass Sorrel Mackall Jr., Benjamin Mackall, and William Whann Mackall. Lucy and Dottie are seen here around 1900. (Douglass Sorrel Mackall III.)

Otrich Sharper Jackson Costley
Otrich, the daughter of Selone Boston and Frederick Douglas Sharper, was born in 1900. Her father was a farmer at Langley. The family later moved to Odrick's Corner, a black community along Lewinsville Road. Otrich married Mott Jackson and then Cornelius Costley. Names like Sharper, Boston, Jackson, and Costley were significant around Odrick's Corner, Bellevue Road, and the formation of Pleasant Grove Church. (McLean Community Center.)

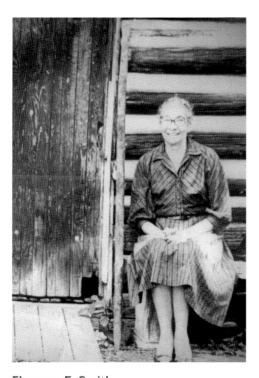

Florence E. Smith
This 1978 photograph shows Florence Smith, the daughter of Eliza and Harvey Boston, seated in front of the cabin where she was born. The cabin, located on Georgetown Pike near Swinks Mill Road, was built by her grandfather, William Henry Boston, and taken down shortly after this photograph was taken. (McLean Community Center.)

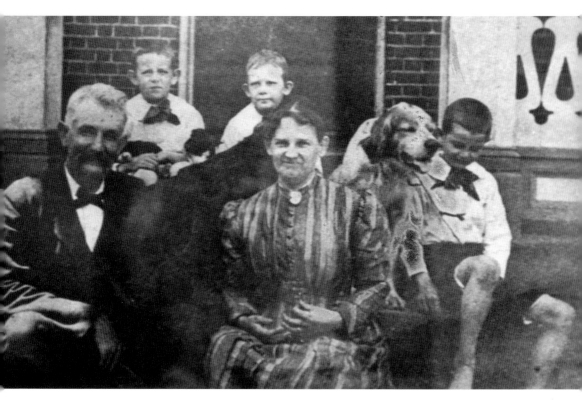

Smoot Family

A 208-acre farm known as Salona was purchased by Jacob Gilliam Smoot in 1853. It was part of Thomas Lee's land grant of 1719. Jacob established a prosperous working farm that included registered Aberdeen Angus cattle. During the Civil War, Jacob, a secessionist, vacated Salona for Georgetown when Federal troops arrived in October 1861. Union general William Farrar "Baldy" Smith used Salona's brick mansion for his headquarters, and the Vermont Brigade encamped on the surrounding property. After the war, Jacob and his wife, Harriet, returned to Salona with their four children. Jacob filed with the Southern Claims Commission for property damages, but was denied compensation because he supported the Ordinance of Secession. Their three daughters never married and remained at Salona. Before Jacob died in 1875, his son, William, took over management of the farm, and William's wife, Jennie, entertained. They had three sons: John D.K., William Jr., and Gilliam. Upon reaching adulthood, two of their sons moved elsewhere, but Gilliam remained and gradually took over the farming operations. William Sr. died in 1900, leaving his share of Salona to his widow. After Jennie's death, her portion was divided among their three sons, and, because her husband's sisters remained single, their share eventually went to her three children. Gilliam also never married, but lived in the mansion house and farmed the land. Both of his brothers died intestate. John's portion went to his widow, Julia, and it was later divided among their children, Jane, John D.K. Jr., and Henry. The share held by William Jr., went to his widow, Elizabeth, and their two sons, John J. and William III.

As Gilliam grew older, he found farming difficult and, after World War II, Salona began to decline. Gilliam rented the land for use as pasture and moved from the house to a nearby residence. Salona fell into disrepair, and none of the Smoots wanted to permanently live there. In 1948, the family partitioned the property. Gilliam received 65 acres that included the house. Susan and Clive DuVal purchased most of Gilliam's section beginning in 1953. After 100 years, the Salona mansion was no longer in the Smoot family. The DuVals restored the historic house and opened it to the community for special events. This 1892 photograph shows William Sotheron Smoot, his wife, Jennie Kurtz Smoot, and their three boys, John (left), William (center), and Gilliam. (McLean Community Center.)

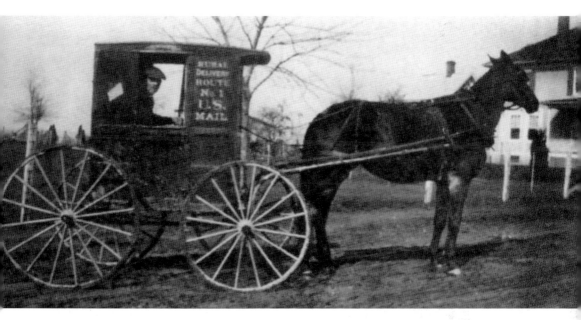

Arthur Taylor
"Pop" Taylor was appointed postmaster at Langley on February 7, 1882, and served until Braden Hummer took over the position in February 1886. Arthur was a founding member of the McLean Volunteer Fire Department and was McLean's first rural mail carrier. He is seen here in McLean's initial mail wagon around 1920. (*McLean Remembers.*)

Samuel Caylor
In the early 1900s, Civil War veteran Samuel Caylor lived in McLean with his daughter Maria and her husband, Elmer Stoy. During the war, Samuel Caylor was attached to the Loudoun Light Artillery, Fauquier Artillery. He was captured at Suffolk, Virginia, exchanged, and sent to the Richmond General Hospital. In 1865, he surrendered at Edwards Ferry, Maryland. Samuel died in 1918. He is shown at the Stoy's house on Elm Street. (Ann Hennings.)

Wilfred Faulkner

Faulkner was born in 1871 in the pre–Civil War family farmhouse that still remains at Chesterbrook and Kirby Roads. He farmed 10 acres, growing vegetables and maintaining fruit and nut trees. On Saturdays, he took his produce into Washington, initially by horse and wagon, but later by truck. He is shown here on the farm with his wife, Katie, whom he met at a District market. (Elaine Strawser Cherry.)

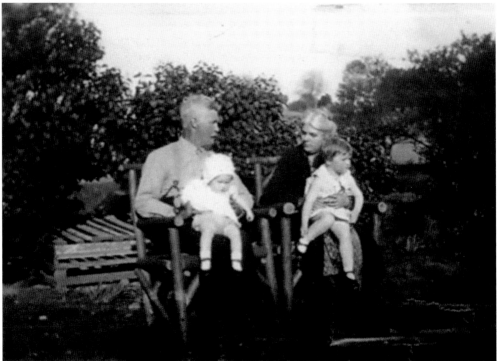

James Lucien Hall

James, known as Lucien, was born in 1875 in the house in which he lived throughout his life. He farmed his property, which consisted of 49 acres located along Linway Terrace and, partly, the Great Falls & Old Dominion Railroad during its years of operation. Lucien is shown around 1930 with his wife, Mary. They are holding two of their grandchildren, Audrey (left) and Virginia. (Elaine Strawser Cherry.)

Inez Jenkins Stalcup

A one-room Chesterbrook School opened in 1906 on Linway Terrace, and Inez Jenkins was its first teacher/principal. She married Guy Stalcup in 1908 and retired from teaching. Inez later took over a small concession on Kirby Road operated by her mother. It was expanded into the Chesterbrook General Store, a family business that accommodated the needs of the local residents, who were mainly farmers. (Stalcup family.)

Dr. Jackson Anderson

Jackson Anderson established his medical practice in Lewinsville in 1896. He operated from his home and made house calls by horse and buggy. He later married Ida Hunt. They had three children before moving to Fauquier County in 1917. The family returned to McLean in 1924, and Dr. Anderson continued to practice out of his house (located where the Balls Hill Government Center is today) until the mid-1940s. (*Northern Virginia Heritage.*)

Matthew Laughlin

In 1881, Matthew Laughlin, who built streets in Washington, purchased 130 acres along the east side of Chain Bridge Road between Langley and Lewinsville. He built a house, named Lindenhurst, and farmed the land. The Ingleside subdivision was platted in concert with the arrival of the GF&OD, and, in 1906, Matthew purchased a lot at Chain Bridge Road and the rail tracks. He built a farmhouse from which his son James Clifton Laughlin (called Clifton) operated a real estate business. This 1902 photograph depicts Matthew (seated lower right) in front of a neighbor's house with Dr. William Hazen (standing left). Clifton, behind Matthew, stands beside his wife, Emma, the daughter of Dr. Hazen, and her two sisters, Catherine and Elizabeth. Matthew's wife, Ella, is standing second from left. (Kip Laughlin.)

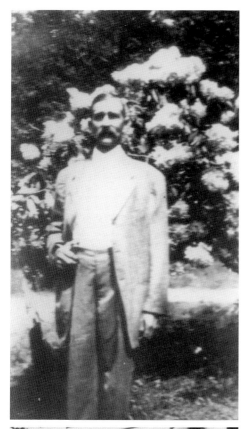

Edward and Keren Magarity Swink
Johnathan and Frances Swink Magarity acquired a gristmill at Georgetown Pike and Scott's Run in 1881. Their daughter Keren (below) and Edward Franklin Swink (above) were deeded the mill property 10 years later and moved into the miller's house. Edward had been operating a sawmill farther up Georgetown Pike in Forestville (now Great Falls). He moved his equipment down to the Scott's Run area and opened a sawmill on the opposite side of Georgetown Pike from the gristmill. Edward was essentially a farmer and employed professional millers to operate the mill and grind the corn, wheat, and rye brought to them by local farmers. The Swinks had nine children, the last four of who were born in the miller's house, which remains today, although greatly altered. (Both, Barrett Swink.)

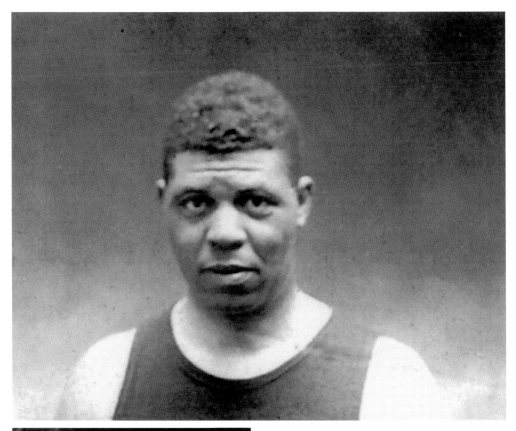

Rufus and Mary Emma Sharper Kenney
Rufus, a Washingtonian who frequently traveled to McLean, married Mary Emma Sharper at Ashgrove Farm in 1912. Mary was born in the Lewinsville area of what later became McLean. She was the daughter of William Sanford Sharper, one of the original seven trustees of Pleasant Grove M.E. Church, established in 1896. Both Rufus and Mary were members of Pleasant Grove Church. He was handy as a carpenter and continually volunteered with church repairs or maintenance at the home of his father-in-law. In the early 1920s, Rufus (above) served as a valet and doorman at the District's Democratic Club. Later, both Mary and Rufus served as caretakers for Massachusetts senator Frank Brandegee. Their daughter, Frances Kenney (Moore), is shown below with Mary around 1916. (Both, Wanda Collins and Sonja Carter.)

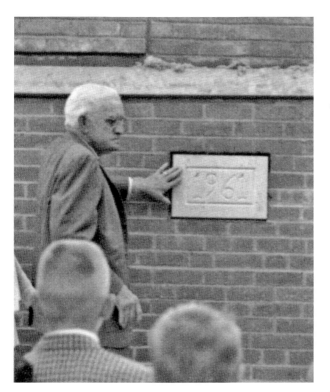

J. Clemons Storm
Clemons, whose brother Henry opened Storm's General Store and Post Office in 1910, took over the dairy farm of his father, John Storm. He expanded the herd to about 125 cows, and the milk was sold to Chestnut Farms Dairy. The farm reached its peak during World War II. Clemons is seen here in 1961 beside the cornerstone of the educational building for Lewinsville Presbyterian Church. (Maynard Kidwell.)

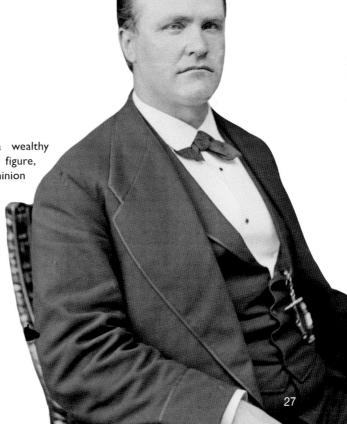

Stephen Elkins
Along with John McLean, Elkins, a wealthy businessman and powerful political figure, promoted the Great Falls & Old Dominion Railroad. The stop at Georgetown Turnpike was named after him. Along with his father-in-law, Henry Gassaway Davis, he founded Davis and Elkins College in West Virginia and was secretary of war under Benjamin Harrison before becoming a US senator from West Virginia. (Library of Congress.)

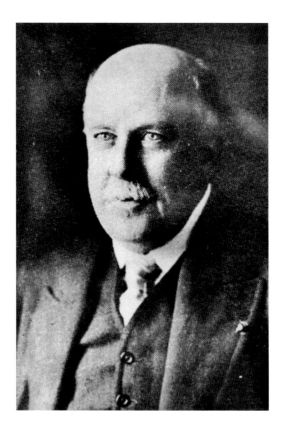

John Roll McLean

The village that became known as McLean was named after John Roll McLean, who inherited the *Cincinnati Enquirer* and used it to promote democratic politics. He later moved to Washington, where he became president of the Washington Gas Light Company, director of two banks, and, in 1905, owner of the *Washington Post*. This was the era of the electrified railroad. McLean partnered with another wealthy entrepreneur, Sen. Stephen B. Elkins of West Virginia, to build the GF&OD, a 14-mile trolley line that operated between Rosslyn and Great Falls Park. Both men envisioned further financial prosperity from this operation. It was purely a business venture designed to promote the natural beauty of the Great Falls of the Potomac River, but the park also had historic interest. The park held remains of George Washington's Patowmack Canal operations and ruins of Matildaville. The trolley's first scheduled run to the park occurred on July 3, 1906, and the first trip carrying passengers took place on the following day. Communities sprang up at stops along the route. The stop at Chain Bridge Road was originally named Ingleside, but by 1910, it was called McLean. As a powerful political figure and wealthy entrepreneur, McLean probably never set foot at the McLean stop. He lived in the District of Columbia, off of Wisconsin Avenue, on a 70-acre estate called Friendship (McLean Gardens today).

Elkins died in 1911, and his son, Davis, took over management of his father's estate. McLean died from cancer in 1916. His only son, Edward (Ned), was not interested in furthering his father's business interests. Ned, along with his wife, Evalyn Walsh, a gold-mining heiress, led a lavish lifestyle and proceeded to go through both of their fortunes. They were intimate friends of President Warren Harding and his wife, Florence. At one time, Evalyn owned the Hope Diamond. Ned was shamefully involved in the Teapot Dome scandal, led the *Washington Post* into bankruptcy, and wound up in a mental hospital. As the automobile gained in popularity, ridership on the railroad declined. Estate lawyers for Elkins and McLean were not willing to put more money into a failing operation. The trolley went into receivership in 1932. In 1934, the route was abandoned, and its roadbed was later paved to become Old Dominion Drive. (McLean Community Center.)

CHAPTER TWO

A Village Forms

1910–1940

The arrival of the electrified Great Falls & Old Dominion Railroad had a tremendous impact on the area. Residents and businesses found it important to be located near the McLean stop, and the community simply developed around it. At first, the stop was called Ingleside, but, in 1910, the name was changed to McLean. The consolidation of the post offices at Chesterbrook, Lewinsville, and Langley in 1911 into one named McLean solidified the significance of the McLean stop. The post office operated from inside Storm's General Store, which was adjacent to the tracks.

The Franklin Sherman School opened near the stop in 1914, and, that same year, the School and Civic League formed. The league established McLean Day, a day-long country fair, the following year as a means of financially assisting the school. The McLean Volunteer Fire Department took over the operations of McLean Day in 1926 as a way to raise funds for the station, renaming it the McLean Carnival and turning it into a three-day celebration. In 1932, a large two-story attachment was added to the rear of the firehouse. Vehicles and equipment were kept on the lower level, while the upper level was used for local meetings, dinners, and fundraising events. Without a civic center, the firehouse became the community center for McLean.

New families came to McLean and bought homes in the Ingleside subdivision. These residents were not farmers, but were families of commuters. In the mid-1920s, Frank Walter contracted with Sears, Roebuck & Co. to build its prefabricated houses in an area of McLean known as Walter Heights. Each prepackaged Sears house arrived by rail and was unloaded at the siding beside Storm's Store. Everything was then hauled to the property site, where the home was assembled. This was followed by a gradual development of West McLean.

Over time, ridership on the GF&OD declined, and the service offered to its passengers was questionable. The company was forced into receivership. In 1934, after 28 years of service, the Great Falls & Old Dominion Railroad abandoned its route and exchanged the property for unpaid taxes. The tracks were taken up. The roadbed was paved with asphalt, and, in remembrance of the railway, the new road between Cherrydale and Great Falls was named Old Dominion Drive.

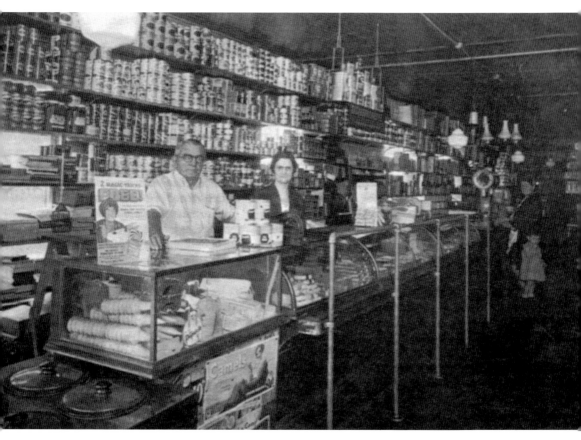

Henry Alonzo Storm

In April 1910, John Storm, a prosperous dairy farmer, purchased property adjacent to the tracks of the Great Falls & Old Dominion Railroad, which included a general store. The building was razed, and a new structure was built on the foundations of the old one. One of his sons, Henry Alonzo "Lonnie" Storm, was appointed McLean's first postmaster and opened Storm's General Store and Post Office in June 1910. The store also served the community by providing space for meetings and as a gathering spot for local residents. It was not a train depot, but tickets could be purchased inside the store. As the automobile grew in popularity, Storm's dispensed gasoline from pumps in front of the store. "Lonnie" Storm is seen here behind the counter in 1939 with Myrtle Kidwell. (*McLean Remembers.*)

James Beatty
The first president of the McLean Volunteer Fire Department was James Beatty. He served in this position from January 23, 1923, until January 27, 1936. It was on a small portion of his property along Chain Bridge Road that McLean's first firehouse was built in 1925. (McLean Volunteer Fire Department.)

Charlotte Troughton Corner
In October 1914, the Franklin Sherman School, the first public school in Fairfax County, opened in McLean with 29 students and Charlotte Troughton as principal. The following year, she married Theodore Corner. In those days, a woman could not teach or be a principal if she was married. Consequently, Charlotte held the position only one year, but she was one of McLean's leaders the remainder of her life. (McLean Community Center.)

31

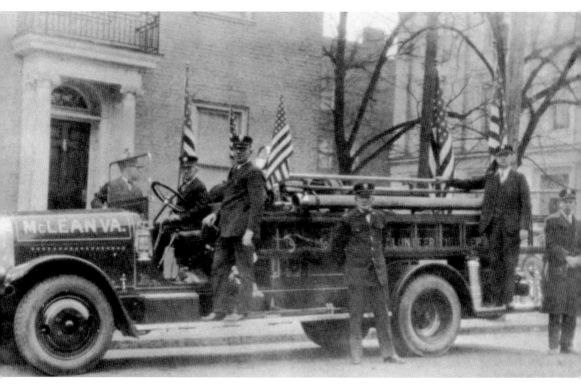

McLean Volunteer Firemen
The McLean Volunteer Fire Department incorporated in 1923. Its members built a cinder-block, two-bay structure on Chain Bridge Road and Cedar Street (now Redmond Avenue) in 1925. This was the first firehouse in Fairfax County, designated Station No. 1. Besides fighting fires, the volunteers sponsored, supported, and participated in community events, including parades. Here, six of McLean's firefighters pose in front of their Brockway Pumper at a George Washington Birthday Parade in Alexandria. They are, from left to right, Albert Gorham, Arthur "Pop" Taylor, Joe Kefauver, John Carper, Harry Farver, and Charles Magarity. (McLean Volunteer Fire Department.)

Eppa Kirby
For nearly 20 years (1928–1947), Eppa Kirby was the sheriff for Fairfax County. He was known as the "No-Gun Sheriff," because he never carried a firearm. He lived with his wife, Beulah, on a farm at the northeast corner of Kirby Road and what today is Westmoreland Street. Kirby was instrumental in establishing a "stand-alone" police department for Fairfax County in 1940. (*Fairfax Herald*, March 18, 1927.)

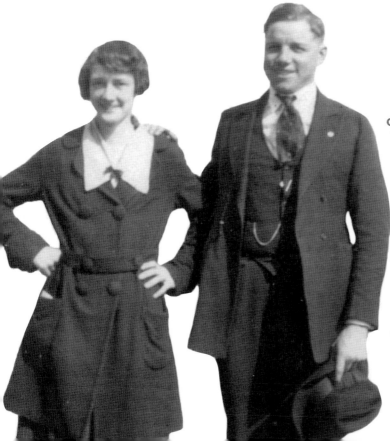

Carl McIntosh
The Fairfax County Police Department organized and became its own agency on July 1, 1940. Carl McIntosh, a deputy sheriff at that time, became Fairfax County's first chief of police, with five sworn police offices and two clerks. He lived in the Chesterbrook area of McLean. The photograph depicts Carl and his wife, Jessie Hill. (Janet Beall.)

Edmund and Marietta Arnold
Edmund Arnold came to McLean in
the early 1920s. He married Marietta
Fruit, a teacher at the Franklin Sherman
School who later taught home-bound
special education children throughout
Fairfax County. Edmund retired from the
Washington Gas Light Company after 30
years of service. In addition to building a
Sears & Roebuck house on Chain Bridge
Road, they attended Trinity Methodist
Church at Langley. (Ann Hennings.)

Maria Caylor Stoy
Maria Stoy, shown here around 1920, was
active in the Langley Methodist Church.
The family lived on Elm Street, directly
across from Storm's General Store and
Post Office. At this location, she raised
her three children, Virginia, Robert,
and Elmer. Maria was an operator at
the Bureau of Printing and Engraving in
Washington, DC, from 1912 to 1940 and
assisted at Storm's Store. (Robert Stoy.)

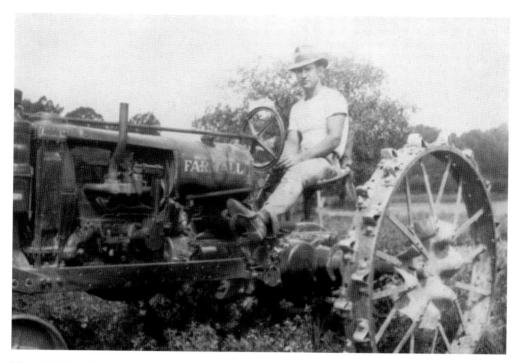

Harold Esler Heath

In 1898, Edward Heath purchased property along Old Chesterbrook Road and farmed the land. A 1937 Farmall F-12 tractor was purchased in 1939. Edward's son, Harold, is shown aboard the Farmall F-12, which had steel wheels with cleats and was started with a hand crank. The Heaths sold their produce from their side yard and to the District commission houses. Harold sold all but two acres in 1959. (Gary Heath.)

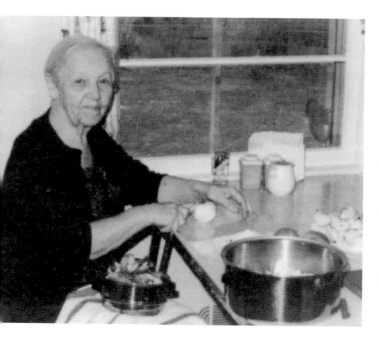

Allie Lee Carter

Because both her daughter Rebecca and son-in-law George Hennings worked, Allie Carter moved into their home on Curran Street to run the household after her husband died in 1936. She enjoyed cooking, but had grown up in a time when people grew their own food and did their own canning. She is shown here during one of her canning afternoons. (Ann Hennings.)

35

James Clifton Laughlin

The c. 1904 photograph shows James Clifton Laughlin as a student at Georgetown University. He married Emma Hazen, and they resided at Lindenhurst. "Cliff," a prosperous dairy farmer, was prominent in the affairs of Fairfax County, serving as a justice of the peace and president of the Fairfax Fair Association. He was continually active in the area's real-estate business and established Clifton Laughlin Real Estate around 1932. (Kip Laughlin.)

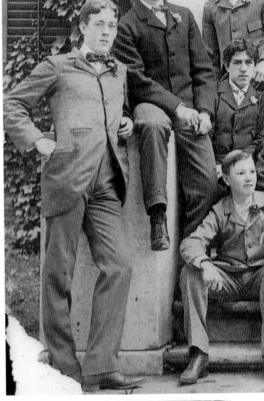

Clifton Hazen Laughlin

Laughlin took over the operations of Clifton Laughlin Real Estate upon the death of his father, James Clifton Laughton, in 1934. He altered the name of the firm to Clifton H. Laughlin Real Estate and continued real-estate and brokerage development from the farmhouse, later known as the "Blue House," at Chain Bridge Road across from Storm's Store. (Kip Laughlin.)

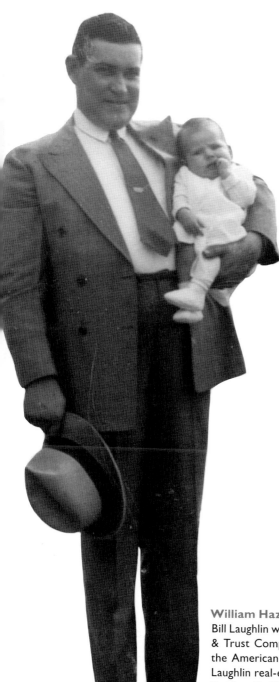

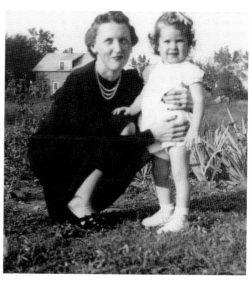

Elizabeth Wells Hall (ABOVE)
Elizabeth Wells worked in the insurance business that William and Clifton Hazen Laughlin II took over in 1934 upon the death of their father, Clifton Laughlin. She married Carlyle "Butch" Hall. William passed away in 1948. Elizabeth took over the insurance portion of the Laughlin family business, which became the Elizabeth Wells Hall Insurance Agency. She is shown here in 1940 with Gloria Laughlin. (Gloria Laughlin Klinger.)

William Hazen Laughlin (LEFT)
Bill Laughlin was in the banking industry with the Washington Loan & Trust Company and was president of the District Chapter of the American Banking Institute. He left banking to continue the Laughlin real-estate operations in McLean. Bill died in 1948 at age 41. His wife, Kathryn "Kitty" Compton Laughlin, then formed Mrs. William H. Laughlin Realtor. Bill is shown here around 1937 with daughter Gloria. (Kip Laughlin.)

Lew Magarity
Not long ago, there was a landmark windmill on Westmoreland Street owned by Lew Magarity, McLean's first school bus driver. He started out with one cow on Ingleside Avenue, but moved to a larger piece of property on Westmoreland Street, where he kept a large dairy herd. Magarity enjoyed the life of a dairy farmer and his windmill. He is shown here as a farmer. (*McLean Remembers Again.*)

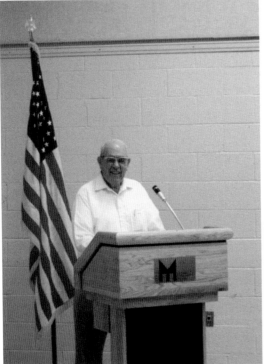

Thomas Corner
Tom Corner, a son of Charlotte and Theodore Corner, was active in the community, serving with the McLean Volunteer Fire Department Station No. 1. In later years, he operated a repair shop next to the family home that still stands at Elm Street and Beverly Avenue. Corner, best remembered as McLean's premier historian, is shown speaking before the McLean Historical Society in 2002. (McLean Historical Society.)

Norman Knauss
Returning home from Franklin Sherman School on May 24, 1929, nine-year-old "Buddy" Knauss ran around the back of the school bus and was mortality hit by an automobile while crossing the road. His mother and two sisters were nearby and witnessed the event. This accident was the impetus for enacting laws requiring motorists to halt when a school bus stops. (Dariel Knauss Van Wagoner.)

Pat Strawser
Pat Strawser stands with his wife, Selma, on their honeymoon in 1930. He was one of McLean's first volunteer firemen. Pat played baseball, trying out for the Washington Senators, but he declined their offer to return. Instead, he pitched for local teams. Strawser pitched for the Clarendon Business Men's Team in 1934 and was the league's leading pitcher while maintaining a batting average over .350. (Elaine Strawser Cherry.)

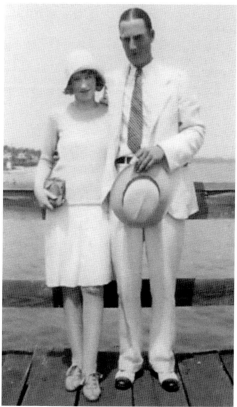

French L. Trammell
In 1910, Trammel began building a farmhouse called Woodbine. The following year, he was deeded 50 acres of land at Balls Hill and Churchill Roads that included the house. He built a dairy barn and began operation. French married Beulah Daffer in 1914. They had four children: Joseph, French A., Anne, and Nancy. French L. died in 1948, and his son Joseph took over farm operations. Joseph began selling the land between 1957 and 1966 for development of Langley Manor, a subdivision of single-family houses, and Churchill Road Elementary School. Beulah remained in the house until her death in 1971. Woodbine remains today adjacent to the school. French A. Trammell is shown next to the house in his sergeant's dress uniform before he left for the Pacific theater during World War II. (Libby Trammell.)

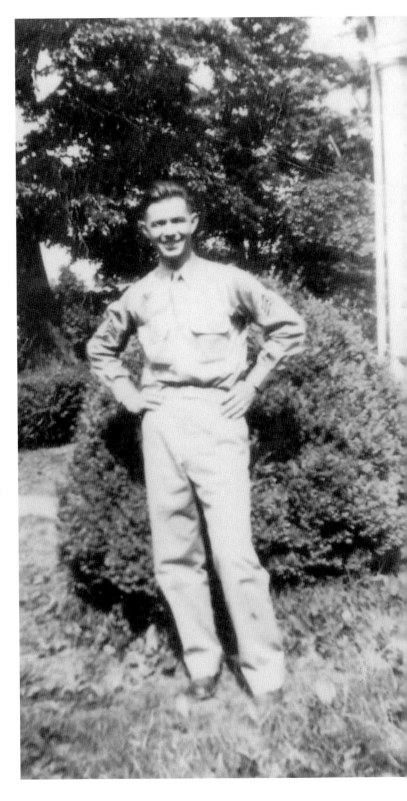

Frank Lyon

After purchasing property in what became
Arlington County, Frank Lyon, a lawyer and
real-estate developer, platted Lyon Village
and Lyon Park. His firm, Lyon & Fitch, sold
the lots for single-family residences. He
moved to McLean in 1923 and, using stones
from Pimmit Run, built a magnificent home,
naming his estate Franklyon Farm. Later,
owner Harry Newman changed the name to
Ballantrae. (Arlington County Public Library.)

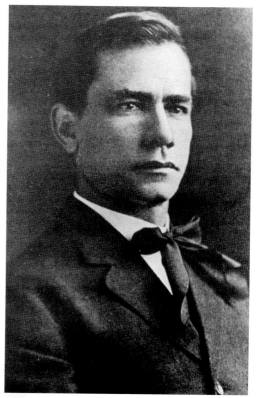

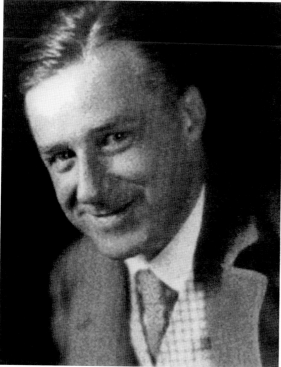

Percy Crosby

In October 1929, Percy Crosby, author
of the *Skippy* syndicated comic strip,
moved to McLean with his second wife,
Agnes. He purchased the adjoining
Franklyon Farm in 1932, renaming it
Ridgelawn. In the wake of the kidnapping
of Charles Lindbergh's baby, Crosby
took measures to protect his children.
Ridgelawn was guarded and surrounded
with iron fencing. Crosby encountered
financial difficulties, and Harry Newman
acquired the property and called it
Ballantrae. (Joan Crosby Tibbetts.)

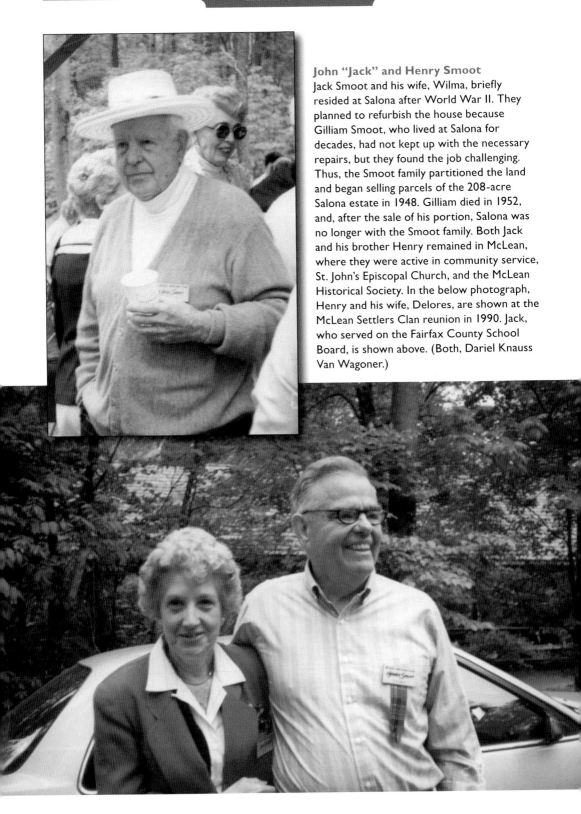

John "Jack" and Henry Smoot
Jack Smoot and his wife, Wilma, briefly resided at Salona after World War II. They planned to refurbish the house because Gilliam Smoot, who lived at Salona for decades, had not kept up with the necessary repairs, but they found the job challenging. Thus, the Smoot family partitioned the land and began selling parcels of the 208-acre Salona estate in 1948. Gilliam died in 1952, and, after the sale of his portion, Salona was no longer with the Smoot family. Both Jack and his brother Henry remained in McLean, where they were active in community service, St. John's Episcopal Church, and the McLean Historical Society. In the below photograph, Henry and his wife, Delores, are shown at the McLean Settlers Clan reunion in 1990. Jack, who served on the Fairfax County School Board, is shown above. (Both, Dariel Knauss Van Wagoner.)

Joseph Leiter

Joseph's father, Levi Leiter, founded what became Marshall Fields and Company. Joseph tried unsuccessfully to corner the wheat market beginning in 1897. In 1912, he and his wife, Juliette, built a 72-room summer home, surrounded by 600 acres, on the Potomac in Langley. He died in 1932. The estate remained vacant and was destroyed by fire in 1942. The CIA located on Leiter's property. (Library of Congress.)

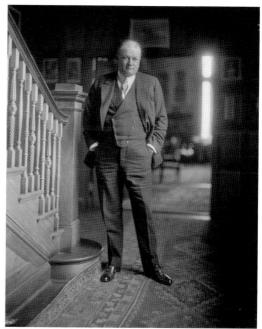

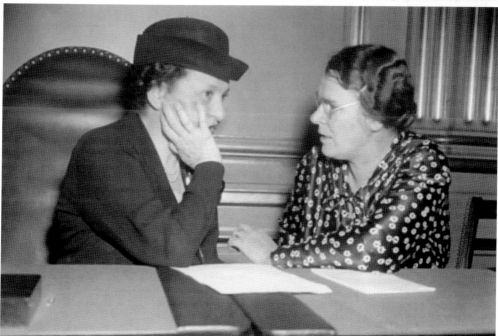

Clara Mortensen Beyer

Clara, an advocate for women's rights, consumer affairs, and social issues, became secretary of the District's Minimum Wage Board after World War I and moved to McLean's Spring Hill Farm after marrying Otto Beyer in 1920. She was influential in Franklin Roosevelt's New Deal administration regarding child labor, worker safety, maximum working hours, minimum wages, and Social Security. Clara (right) is shown here with Labor Secretary Frances Perkins. (Congressman Don Beyer.)

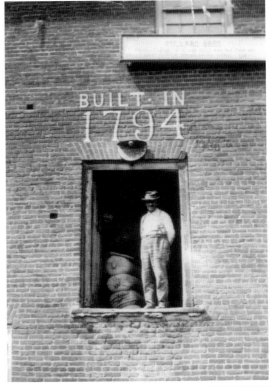

Samuel Millard
Addison Millard purchased Colvin Run Mill in 1883. After his death in 1898, his widow, Emma, and two of their sons, Alfred and Samuel, continued the milling operations. Beginning in 1921, the two sons, who were interested in improved methods of milling and nutrition, operated the mill until 1934. Samuel, who ground and sold Millard's Health Flour, stands inside the opening of the loading dock. (Virginia McGavin Rita.)

Virginia Millard McGavin
McGavin was born in the Millard farmhouse at Colvin Run Mill, owned by her parents, Samuel and Olive Millard. She attended Colvin Run School and married Charles McGavin in 1943. She began working for Fairfax County Public Schools as a cafeteria manager in 1950 and was at the Franklin Sherman, Lemon Road, and Lewinsville Elementary Schools. McGavin is shown pitching hay as a young woman. (Virginia McGavin Rita.)

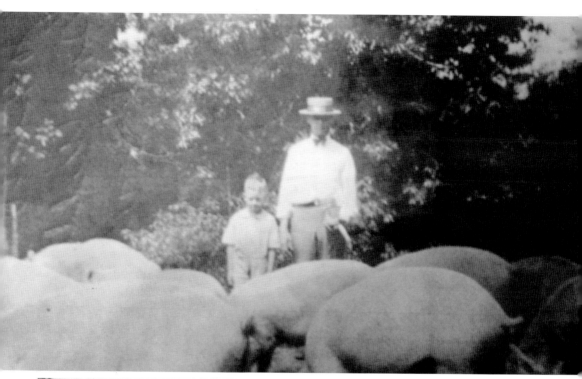

John Wheat

Wheat owned P.T. Morgan and Company, a feed store located in Washington and Virginia. He also operated a mill, where he ground feed for animals. He raised hogs on his farm and would take them to a slaughterhouse in Baltimore. During World War II, Wheat served as an air-raid warden. Wheat is shown with his son Willie around 1930, standing behind some of his hogs. (Mike Wheat.)

Beverly Byrnes Muenster Twombly

Beverly Twombly, shown on an unidentified bridge in 1935, was the daughter of James and Bertha "Bertie" Byrnes, owners of a large dairy farm in the Chesterbrook area of McLean. Her father was an active participant in local political campaigns and real estate development. The family attended the Chesterbrook United Methodist Church. When the farm was later developed, Beverly Avenue was named in her honor. (Gary Heath.)

Lois Hill Beall
Beall grew up in the Chesterbrook area of McLean. Her parents, Harry and Adeline Hill, were dairy farmers and founding members of Chesterbrook United Methodist Church. Lois and Gilbert Beall married in 1925, and the couple made a living as truck farmers. Lois, who enjoyed flowers, is shown putting together arrangements for one of the many organizations to which she belonged. (Carole Herrick.)

Philip Graves
In 2007, McLean & Great Falls Celebrate Virginia, Inc. honored historic homes by marking them with a bronze plaque. Here, Philip Graves receives a plaque from Barbara Smith for his Sears & Roebuck prefabricated house that is part of Walter Heights, a community constructed entirely with Sears homes. The home was assembled by his father, Warren Graves, in 1926, and it remains the same today. (Carole Herrick.)

John and Elsie Arnold Payne
The Paynes lived on Poplar Street (Beverly Avenue), where they raised two daughters, Jean and Betty Lou, as well as Bertha Yowell, who married Tom Corner. John was active in the fire department and often served as treasurer for the carnival. Elsie established the first Sunday school at Langley's Trinity Methodist Church and started the cafeteria at Franklin Sherman, where she volunteered for years. (Ann Hennings.)

Lucy Maderia Wing
The Maderia School was founded in Washington, DC, by Lucy Maderia Wing in 1906. After her husband's death in 1926, the school was moved to a location in Virginia on Georgetown Pike, overlooking the Potomac River. The road at that time was tolled, but it was in such a deplorable condition that, in 1934, the school purchased it for $500 and turned it over to the commonwealth. (Julia Merrell Harris.)

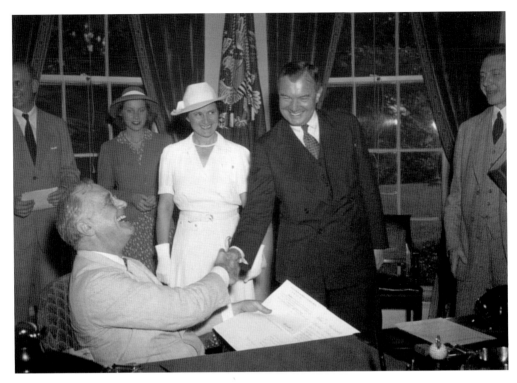

Justice Robert Jackson

After his 1941 appointment by President Franklin Roosevelt to be an associate justice of the Supreme Court, Robert Jackson purchased a home in McLean named Hickory Hill. After renovations, he moved into the house along with his wife, Irene, and their two children, William and Mary. Then, two months later, the Japanese attacked Pearl Harbor, and the United States became involved in a two-front war. The Jacksons attended St. John's Episcopal Church on Chain Bridge Road. They would often arrive by horse and buggy in order to conserve gasoline. Irene did airplane spotter duty at the McLean Volunteer Fire Station. The Jacksons entertained both local residents and government officials. The wedding of their daughter Mary to Dr. Thomas Loftus was held at Hickory Hill in 1943. Her attendant was Jean Wallace, the daughter of Vice President Henry Wallace, and his wife, Ila.

On May 2, 1945, President Truman appointed Jackson to head the United States in an International Military Tribunal, where a court of law would hold leading Nazi figures individually accountable for their war crimes. Such an international trial was unprecedented, as it involved four different systems of law: American, British, French, and Russian. An agreement, known as the London Charter, was reached between the four countries on August 8, 1945, and this became the legal basis for the trial that began on November 20, 1945, in Nuremburg, Germany. There were 24 defendants, but only 22 were tried. Robert Ley committed suicide while in prison, and Gustav Krupt was rendered mentally incompetent. Martin Bormann was tried in absentia. Adolf Hitler, Heinrich Himmler, and Joseph Goebbels were not tried, because each had committed suicide earlier. A guilty verdict was imposed on 19 of the 22 defendants: 12 were sentenced to death, 7 received prison sentences, and 3 were acquitted.

Jackson returned home in time for the Supreme Court's October 1946 session. Shortly after the court handed down its 1954 *Brown vs. Board of Education* desegregation decision, Jackson suffered a fatal heart attack, on October 11, 1954. Irene remained at Hickory Hill through the following winter, but in the spring, she put the house up for sale. Hickory Hill was sold to Sen. John and Jacqueline Kennedy, and Irene moved into Washington, DC. Shown here are President Roosevelt (seated), Mary Jackson (second from left), Irene Jackson (in white), and Robert Jackson at Jackson's 1941 swearing-in ceremonies in Roosevelt's office. (Library of Congress.)

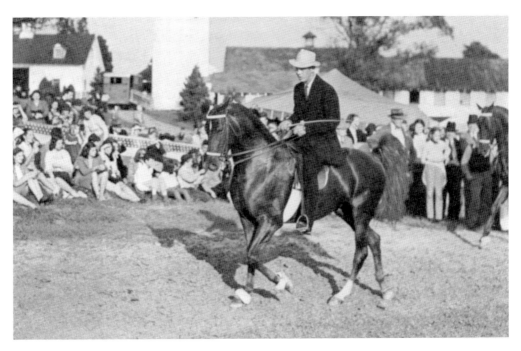

Howard England

Along with Dick Hinkle, Howard England opened McLean Hardware on Old Dominion Drive on July 5, 1948. At first, business was slow, but, as McLean began to grow, so did McLean Hardware. England, known for his horsemanship, is shown in the early 1940s at the annual horse show held on the grounds of Ballantrae to benefit the McLean Volunteer Fire Department. (*McLean Remembers Again.*)

Richard McAllister Smith

In 1944, Richard Smith founded McLean's first newspaper, a weekly called *The Providence Journal*, which he sold to Bill Elvin in 1956. He also owned the McLean Water Company. Water tanks were located on Chelsea Road and Ingleside Avenue, but the mains only served nearby residents. Smith sold the company in 1951 to the Falls Church Water Company. (Historical Society of Fairfax County.)

Louisa Hayes Arnold

Louisa and her husband, William Arnold, lived on Balls Hill Road in what became the office of the Langley School. There, they raised the youngest of their seven children as well as three orphans of the Baesgen family. Louisa was active in reopening the Trinity Methodist Church at Langley. William was an artist and carpenter by trade. (Ann Hennings.)

Virginia, Robert, and Elmer Stoy

The three Stoy children are standing on the front porch of their home on Elm Street around 1911. Their parents, Elmer and Maria Caylor Stoy, came to McLean in 1909 and built the house on a site directly across from Storm's Store, where McDonald's opened on December 12, 1961. Robert (center) and Elmer (right) attended the Franklin Sherman School, but Virginia attended school in the District. (Robert Stoy.)

Mary Cline Trueax
Mary Trueax grew up on Ingleside Avenue, where her parents had several acres across from today's McLean Community Center. At one time, her father, Robert Cline, was the minister at the McLean Baptist Church, located on Emerson Avenue. She married Alfred Trueax, a lawyer, who became president of the Arlington Bar Association. Mary was active in McLean Chapter AARP 839 and the McLean Historical Society. (McLean Baptist Church.)

Henry and John Beall
Henry (left) and John Beall (right) pose with Sam Stalcup at the site of Sam's produce stand on Old Dominion Drive. The brothers were two of seven children of Guy and Della Beall, whose farm was on Kirby Road. John trucked fresh produce to District markets and grocery stores in Arlington and Falls Church. Henry later kept the stand in front of their house. (Stalcup family.)

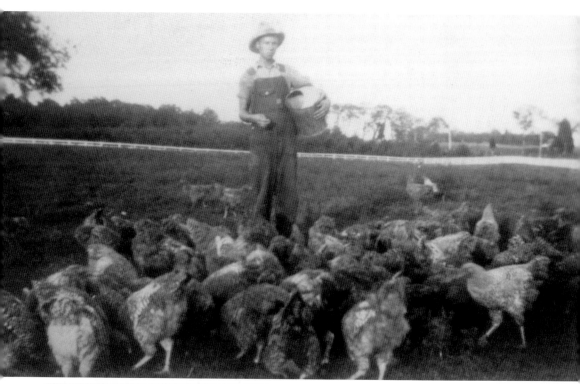

Mason and Mary Peck Smith

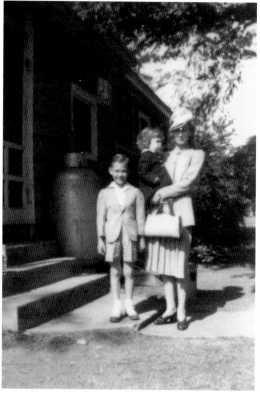

Mason, shown above as a teenager at his family's large dairy farm in Herndon, married Mary Peck in 1933. About 1938, he took over management of Kenilworth Farm in McLean (today Broyhill McLean Estates). The couple had four children: Channing, Ben, Ann, and Leslie. Those that were old enough attended the Franklin Sherman School. Mason managed the farm until 1945, when he bought a small dairy farm that included the Ellmore House, and the family moved back to Herndon. Mary kept the books for the farm, but she enjoyed horses and riding. She raised horses and had Tennessee Walking horses (Walkers). Mason's dairy farm is now part of Frying Pan Park. Below, Mary is shown with Channing and Ann at Kenilworth Farm in 1942 on their way to church. (Joan Smith.)

CHAPTER THREE

Building a Community

1940–1960

The demise of the Great Falls & Old Dominion Railroad had little impact upon McLean. The village was solidly established, and the surrounding area remained agrarian. The automobile was now the dominant mode of travel. Residents often carpooled into the District, particularly during World War II, when gas was rationed. The community had grown enough that the Arnold Bus Line found it profitable to provide service twice daily to and from the city. McLean's first strip mall, built in 1925 on Chain Bridge Road behind the Laughlin House, now contained a Sanitary Market, Doc Jones Pharmacy, Kearns Restaurant, and the office for *The Providence Journal*. Storm's Store was sold to Izzy and Hilda Katz in 1942 and was turned into a DGS (District Grocery Store). The fire station, with its large upstairs room and kitchen, continued to be the community center for the area. In 1947, the original cinder-block firehouse was taken down and replaced with a one-story structure containing four bays.

Construction of numerous and affordable single-family homes began in the District's suburbs after World War II, as many veterans and government employees decided to remain in or near Washington, DC, including the McLean area. With the imminent consolidation and relocation of the CIA to Langley, more residents, desirous of living near their jobsite, moved into newly constructed neighborhoods such as Salona Village, West Lewinsville, Rosemont, Southridge, Broyhill Langley Estates, and Pimmit Hills. This brought new businesses, such as Burns Brothers Cleaners, Enrico's, Herman's Delicatessen (today's McLean Family Restaurant), and McLean Hardware. A supermarket, the Giant Store, became part of a new shopping center on Chain Bridge Road adjacent to the fire station. However, the beginning of McLean's population growth can be seen through its public school system, as many new schools were built: McLean High School (1955); Lemon Road Elementary School (1956); Kent Gardens Elementary School (1957); and Churchill Road Elementary School (1958).

The departure of the large orchards and dairy farms had begun; all were being replaced with residential and commercial development. With the lack of an overall plan, an amorphous village began to expand in all directions in a hodgepodge fashion from the former trolley stop at Chain Bridge Road.

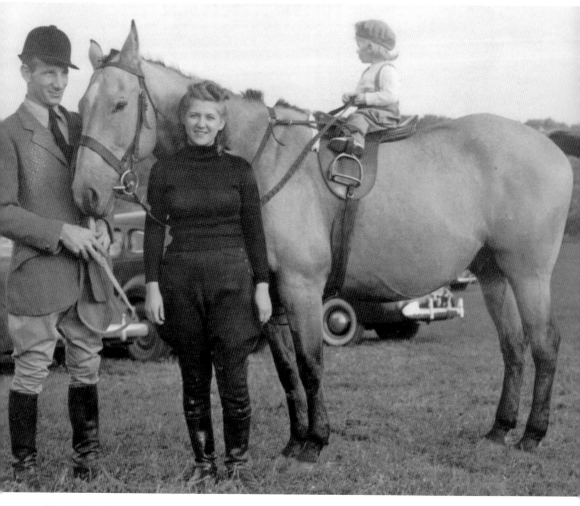

Mark Rhinehart

Horses were Rhinehart's love. He grew up in Langley, where his parents, Vessie and Paul Rhinehart, had a horse farm that included a bed-and-breakfast, riding lessons, rental horses, and a racetrack. Rental horses cost $1 an hour. During World War II, he was stationed along the Atlantic Seaboard and patrolled the beaches on horseback. After the war, Rhinehart rode as a gentleman jockey in horse races at major tracks. This was followed by his opening and operating a bowling center on Chain Bridge Road in McLean with his wife, Annabelle. Mark Rhinehart collapsed and died prematurely in 1971 after winning a race for the Fairfax Hunt at the Potomac Hunt Races. Annabelle continued operating the bowling center. Mark and Annabelle are shown here with their daughter Melinda. (Annabelle Knauss Rhinehart.)

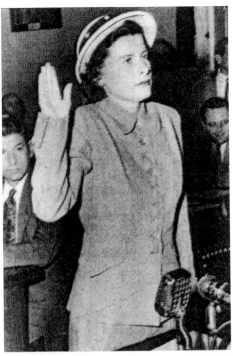

Mary Stalcup Markward
The McLean community ostracized Mary Markward because she joined the District Communist Party. Residents did not know that, during World War II, she worked undercover as a spy, and that, to gather information, she needed to join the party. In 1951, she was sworn in before the House of Un-American Activities and provided valuable information about the party and revealed names of about 250 members. (Inez Dyer Foley.)

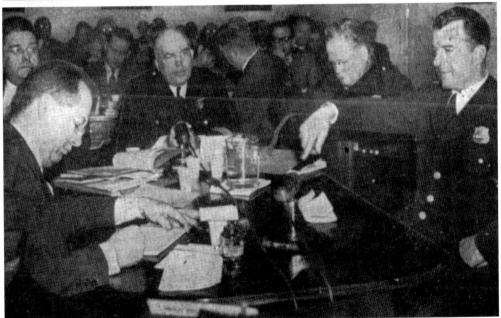

Norman Knauss
Norman and his wife, Julia, moved to McLean shortly after World War I ended. They lived where the McLean Community Center now stands, but later relocated into a Sears & Roebuck home in Walter Heights at Marion Avenue and Chain Bridge Road. Norman was a congressional reporter on Capitol Hill. He is shown here at left, taking the deposition of a "Five Percenter" in 1949. (Dariel Knauss Van Wagoner.)

Hugh Auchincloss

In 1934, Auchincloss, a wealthy lawyer and stockbroker, purchased Merrywood, a 46-acre estate on Chain Bridge Road that overlooked the Potomac River. He later married Janet Bouvier. This was his third marriage and her second. Janet had two daughters, Jacqueline (Kennedy/Onassis) and Lee (Radziwill). When the CIA decided to move its headquarters to McLean, the George Washington Parkway was extended to Chain Bridge Road. Hugh Auchincloss was part of a group that stopped a proposal to widen Chain Bridge Road between Chain Bridge and the parkway; Merrywood remained untouched. In 1963, he sold Merrywood to the Magazine Brothers, developers who planned to build high-rise apartments along the Potomac. Citizen resistance was tremendous. Secretary of the Interior Stewart Udall helped obtain federal funds to buy a conservation easement, and townhouses were built on the remaining property. (John F. Kennedy Presidential Library and Museum.)

John and Jacqueline Bouvier Kennedy

In 1955, a first-term senator from Massachusetts, John Kennedy, and his wife, Jackie, moved into Hickory Hill, a magnificent, white Georgian-style home in rural McLean. Hickory Hill, located on Chain Bridge Road, was about a mile from Merrywood, where Jackie's mother, Janet, and stepfather, Hugh Auchincloss, resided. The Kennedys were planning to start a family. Jackie began to design and decorate a nursery for their first child. She suffered a miscarriage, which was followed by a stillborn daughter a week after the 1956 Democratic Convention. The disappointment of these two losses was great. Jackie no longer wanted to remain at Hickory Hill, so they relocated to Georgetown, and one of John's younger brothers, Robert, and his wife, Ethel, moved into Hickory Hill. (John F. Kennedy Presidential Library and Museum.)

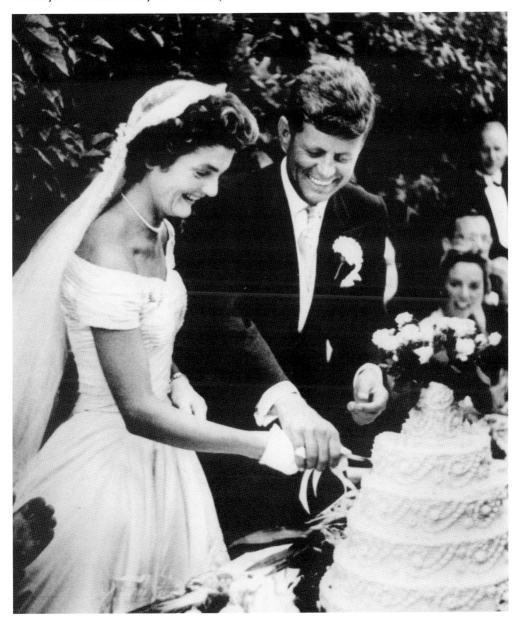

Robert and Don Burns
Burns Brothers Cleaners, the first dry
cleaners in McLean, opened on August 15,
1949, in a freestanding building facing Old
Dominion Drive. Other buildings were
periodically added to form the small strip
named McLean Shopping Center. Burns
Brothers sponsored the Firemen's Ball for
13 years beginning in 1951. Here, Robert
(left) and Don pose during construction
of their business. (Don Burns.)

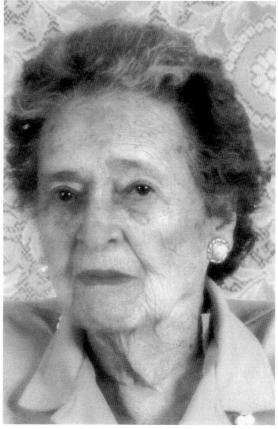

Ruby Dunkum
Dunkum came to McLean in 1931 to
be a teacher at the Franklin Sherman
School. She was the school's principal
in 1954 when the Salk vaccine was given
by Dr. Richard Mulvany to children in
the nation's first polio field test. In 1958,
she became the first principal at the new
Churchill Road Elementary School and
later served as the principal of Springhill
Elementary School. (Robert Stoy.)

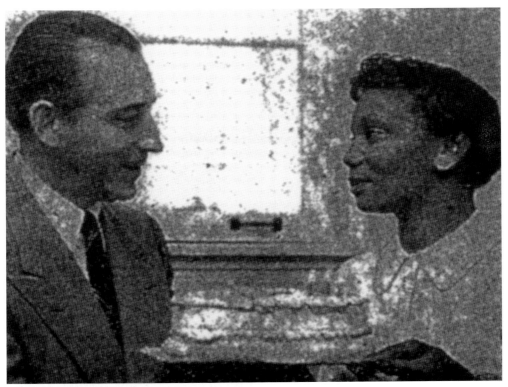

Martina Hall

Hall had a defective aortic valve and received an artificial heart valve on September 11, 1952, from surgery performed by Dr. Charles Hufnagel. She was called the "Tick Tock Woman," because her heartbeat could be heard six feet away. Hall was the first person to survive such an operation, living seven additional years. Here, she and Dr. Hufnagel celebrate the fourth anniversary of her operation. (*Washington Post.*)

Virese Hall Thornton

Virese is a granddaughter of Maria and Christopher Columbus Hall, freed slaves who purchased 26 acres of land from Francis Crocker off Kirby Road in 1865. Christopher farmed the land, taking his produce into Washington. They raised 11 children, giving small parcels to each. The road into the farm is named Cottonwood Street. Many Hall descendants, such as Virese, still reside there. (Roy O'Brien.)

Stanley Mehr
In 1951, Stanley and his brother Seymour purchased four acres of semi-forested land at Balls Hill Road and Old Dominion Drive. The brothers cleared the land and grew dahlias and gladiolas to exhibit and compete in the Washington Botanic Garden Show. They eventually began selling flowers, naming their operation Mehr Brothers Flowers. Stanley is shown here with his wife, Maria, in 2008. (Zoe Sollenberger.)

Elaine Strawser Cherry
Elaine Cherry grew up in the Chesterbrook area of McLean, where five generations of the same family have lived in the pre–Civil War farmhouse that still stands at Kirby and Chesterbrook Roads. A neighbor, William Stalcup, sponsored an annual Great Pumpkin Hunt, which included prizes and a hayride. Cherry is shown here in 1981 after finding a $10 prize taped to the bottom of a pumpkin. (Stalcup family.)

Sam Redmond

The McLean Volunteer Fire Department hired Sam Redmond in 1946 as its first paid employee. This lasted about two years, until Fairfax County began paying half of his wages. In 1949, the county began hiring personnel at an annual salary of $2,500. Sam was the first to be hired. He was given badge No. I and assigned to the McLean station designated as Company No. I. (McLean Volunteer Fire Department.)

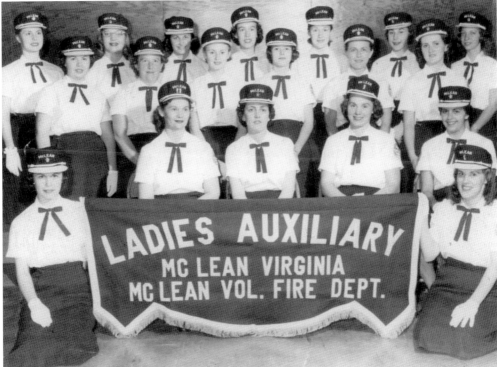

Ladies Auxiliary

The Ladies Auxiliary of the McLean Volunteer Fire Department formed in 1925. It reorganized in 1935 so that the women could support the station in its fundraising efforts by holding bake sales, raffles, dinners, helping with the annual Firemen's Carnival, and providing refreshments for the firefighters during times of emergencies. The women had a marching unit and participated in parades. The auxiliary disbanded in mid-1970. (Libby Trammell.)

John Carper

In 1936, John Carper was elected chief of the McLean Volunteer Fire Department. He maintained that position through 1951, then served as president until December 1969. During World War II, he was appointed fire chief of Fairfax County by the Fairfax County Board of Supervisors. This meant that Carper volunteered to serve as the fire chief for Fairfax County and the McLean station at the same time. As the county's fire chief, Carper's primary role was to ensure, through a state-regulated department known as the War Materials Board, that the county's 11 volunteer fire departments would be able to obtain rationed items, such as replacement tires and gasoline. Carper remained the fire chief for Fairfax County until 1963. At that time, the fire department of Fairfax County reorganized. The position of chief was eliminated and replaced with a Fairfax County fire administrator. Carper also served on the board of the Fairfax County Fire Commission from 1946 to 1960, at one point serving as its chairman. While on this board, he was instrumental in getting mobile radios into fire and rescue vehicles.

Besides volunteering, Carper maintained a business. Along with his cousin, Oswald Carper, he owned and operated the Esso station that stood at today's Chain Bridge Road and Old Dominion Drive. They housed heavy equipment and dump trucks in a barnlike garage behind their filling station. These vehicles were used to haul McLean's topsoil, sold to them by area farmers, into the District. They did this for nearly 10 years. The Federal Triangle was built upon McLean topsoil. Later, the cousins went into contracting. Their first big job was asphalting the rail bed of the GF&OD, converting it into Old Dominion Drive from the Arlington County line out to Great Falls Park. Carper had a reputation for generosity and helping others financially or just through friendship. To commemorate him, a plaque was placed on the outside of McLean's firehouse (today's Old Firehouse Teen Center). Carper was present at the plaque's dedication ceremony in 1970. When the old firehouse was turned into a teen center, the plaque was removed. It hangs today on a wall inside the present firehouse on Laughlin Avenue. (McLean Volunteer Fire Department.)

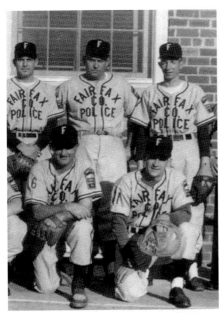

Harold Dailey
Dailey, nicknamed "Rabbit," joined the Fairfax County Police Department in 1951, retiring as a lieutenant in 1979. He served as a private, motorcycle policeman, and detective. At one time, McLean had a baseball team, and Harold was an outfielder. The police department also had a team, on which he played in the outfield and also pitched. Harold is seen here on the right in the top row. (Fairfax County Police Historical Association.)

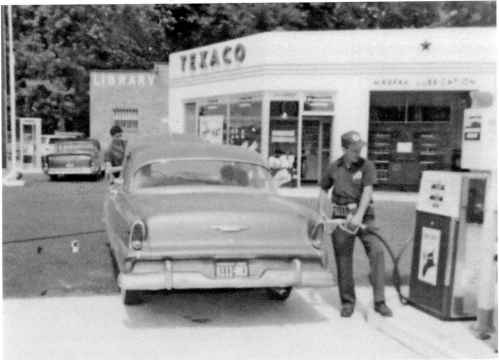

Malcolm Tuthill
The Tuthill family owned and operated Texaco filling stations in Northern Virginia beginning in 1951. Around 1960, a Texaco station operated by Malcolm Tuthill occupied the triangle formed by Old Dominion Drive and Elm Street, where Storm's Store and, later, a District Grocery Store, once stood. McLean had many filling stations and became known as "gasoline alley." Malcolm is shown pumping gas at the McLean station. (Vicky Heckman.)

Frida Frazer Winslow Burling

In 1932, when she was 16, Frida Frazer moved to McLean. Her mother, also named Frida, had married Randolph Leigh and moved from Washington to live at Randolph's home, Ranleigh. This was a magnificent country estate surrounded by 70 acres on Chain Bridge Road, built to look like Mount Vernon. It was the second marriage for both. Randolph had two sons, Randolph and Claiborne, by his previous marriage. The Leighs continually entertained neighbors, government officials, diplomats, and the friends of their children. In 1934, at age 19, Frida made her debut at Ranleigh, an event that was followed by a month of debutante dinners and dances throughout the Washington area. She then joined the Junior League of Washington and later began working in the law firm Culbertson & LeRoy.

Frida soon met Thacher Winslow, who worked at that time for the National Youth Administration. They were married in 1938. By this time, Randolph had been adding buildings to his property. He remodeled a farmhouse and named it Little Ranleigh, which was followed by Lower Ranleigh, built on the opposite hill. He then helped his son Randolph build a house by Pimmit Run. For the newlyweds, Randolph had a small cottage built on the grounds in back of Ranleigh, overlooking Pimmit Run. During World War II, Leigh Randolph went overseas. After he returned, he and Frida divorced. The younger Frida's mother moved to Georgetown, and Thacher and Frida soon followed. That move basically ended Frida's involvement with McLean. In 1955, Thacher had a heart attack and died. Frida married Edward Burling Jr. four years later, and they lived in Georgetown. But they wanted a country home and settled upon Dinwiddie, a 300-acre estate in Middleburg. In 1966, Eddie's father died, bringing about citizen furor over the 336-acre Burling Tract along the Potomac. Developers Miller & Smith proposed building 309 homes on the site and were eventually granted rezoning approval from the board of supervisors. A group of citizens forcefully opposed the plan. The citizens won, and the land was saved as Scott's Run Nature Preserve. Dinwiddie was eventually sold, and the Burlings returned to their Georgetown home. (*Finally Frida.*)

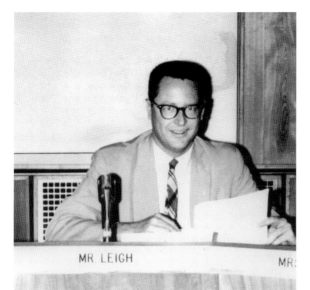

MR. LEIGH MR.

A. Claiborne Leigh
Claiborne grew up at Ranleigh, a home built by his father, Randolph Leigh, facing Chain Bridge Road. He was elected to the Fairfax County Board of Supervisors in 1955, opposing high-rise apartments at Merrywood. He later voted to approve the zoning. Claiborne became involved in another Fairfax County zoning issue involving a bribe, resulting in a brief confinement at Allenwood Correctional Facility. (Fairfax County Public Library Archives.)

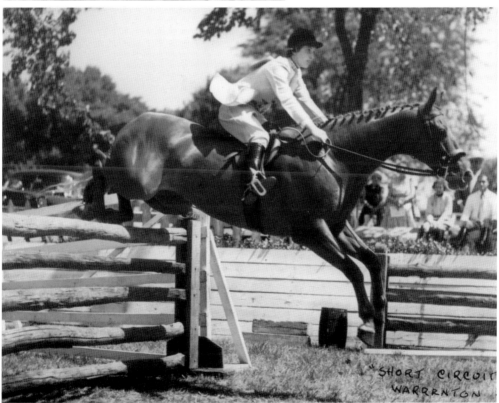

SHORT CIRCUIT
WARRENTON

Caroline Evans Van Wagoner
Caroline Van Wagoner began riding horses at an early age. She competed in East Coast horse shows. Along with her brother Ralph, she fox-hunted with the Fairfax Hunt. She is shown at the Warrenton Horse Show astride Short Circuit, the 1954 Junior Hunter Champion of Virginia. (Caroline Evans Van Wagoner.)

Bayard Evans

Bayard and Ruth Evans moved to McLean with their two children, Ralph and Caroline, in 1941. At that time, Bayard owned and operated the Evans Coffee Shop on Lee Highway in Arlington. He had been accumulating land in McLean, acquiring approximately 43 acres. The family settled into an existing farmhouse on the property, which Bayard remodeled. He farmed the property, taking vegetables and fruit to the coffee shop and, during World War II, bringing produce to the Pentagon. Chickens, geese, ducks, cows, goats, and hogs were part of his farm.

The Evans property was adjacent to the Lewinsville Presbyterian Church. When the church decided to demolish its manse, Bayard purchased it for $1 and had it moved onto his property. He renovated the structure and, in 1949, sold it to Carlton Van Wagoner. In 1954, the original white framed church, built in 1846, was destined to be razed. Bayard also purchased it for $1 and used some of the hand-hewn beams and hand-blown glass for Evans Farm Inn, which he began constructing in 1957. Bricks for the inn came from Sully Plantation, Monticello, Lloyd House in Alexandria, and the Porter mansion in Washington. Weathered boards and heavy timbers came from Johnathan Magarity's nearby farm. The inn opened in 1958. A Colonial atmosphere was presented, with antiques, an array of historical memorabilia, servers in period attire, and plantation-style food. The Sitting Duck Pub, a separate restaurant downstairs, a cookhouse, and a replica mill added to the atmosphere. The old Lewinsville Sunday school building was moved onto the farm property and turned into a country store.

A proposal for a McLean Bypass called for it to go down Chain Bridge Road, destroying numerous structures. Bayard suggested that it pass through the back fields of his farm. Dolley Madison Boulevard opened in 1962 and sliced through Evans Farm; 13 acres were now on the opposite side of the new highway. Bayard was passionate about historic preservation and was involved with restoring Colonial Williamsburg. He formed the Fairfax County Landmarks Preservation Committee, an organization that helped save Colvin Run Mill. He also helped preserve Dranesville Tavern when it was slated to be demolished. Evans founded the McLean Kiwanis Club in 1960 and was named Restaurateur of the Year in 1965 by the Restaurant Association of Metropolitan Washington. Bayard (center) and Ruth are shown inside the inn with Ralph. (Caroline Evans Van Wagoner.)

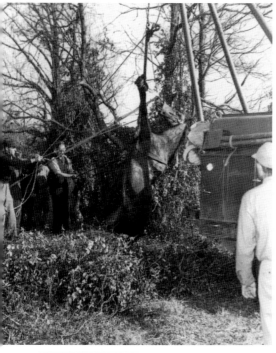

Ruth Evans

Ruth Evans moved to McLean with her husband, Bayard, and two children, Ralph and Caroline, about 1941. At that time, they owned and operated the Evans Coffee Shop on Lee Highway in Arlington. Ruth was riding her hackney pony, Playboy, along Balls Hill Road in 1946 when the animal stepped on a grass-overgrown board that covered an abandoned well. The pony slid hindquarters-first into the well. Ruth threw herself from the saddle, escaping uninjured. With the help of the McLean Volunteer Fire Department, Playboy was lifted from the 30-foot-deep well (left). Playboy only had a few scratches. After comforting him, Ruth walked Playboy home. Ruth (below) was later president of the Fairfax Business and Professional Women's Club and a founding member of the Salvation Army Auxiliary of Fairfax County. (Both, Caroline Evans Van Wagoner.)

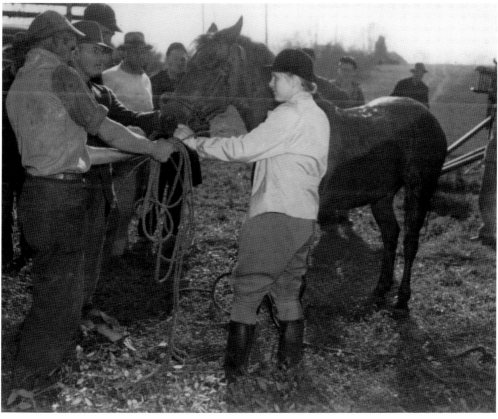

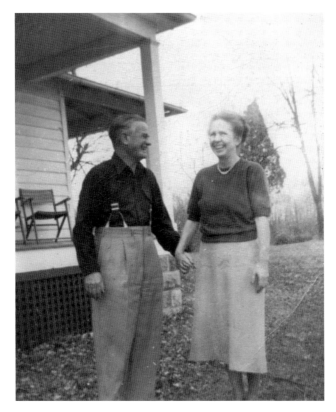

Mark and Marion Merrell

As part of the New Deal, Mark Merrell moved to McLean with his wife, Marion, and daughter, Julia, to head the drug division of the National Recovery Administration. The Merrells eventually moved into the pre–Civil War farmhouse called Rokeby, then owned by the Gantt family, Floyd, Orris, and Adele. Marion was a writer, using her maiden name, Clinch Calkins. Her 1930 book of social criticism, *Some Folks Won't Work*, was a bestseller. As the New Deal got under way, Harry Hopkins asked her to join the Federal Emergency Relief Administration. She traveled the country with Hopkins, reporting on economic conditions, and she was the ghostwriter for his 1936 book *Spending to Save: the Complete Story of Relief*. Marion followed the hearings of Sen. Robert La Follette's Civil Liberty Committee and wrote what she learned in *Spy Overhead*, one of the first books to examine industrial espionage. She then went on to write a play, *State Occasion*, about the rise of an American fascist. It nearly made Broadway; it was produced at Catholic University with Alan Schneider directing and Ed McMahon in a small part.

Marion, a serious poet and writer, helped Marchese Guglielmo Marconi's daughter Degna write a biography of her father, which was published in 1962. During the 1940s, while still working for the government, Mark began purchasing real estate. The first property he bought was on Georgetown Pike near Balls Hill Road, presently owned by the Jerry FitzGeralds. This was followed by his developing Saigon off Georgetown Pike. In 1950, while in Saigon for the Economic Cooperation Administration of the Commerce Department, he received a phone call from his wife about naming the road leading into the development, then under construction. He responded that, since he was in Saigon, the entrance might as well be named Saigon Road. Mark Merrell retired from the government in 1953 and began a new career in earnest, developing land in McLean and Herndon. He developed land near Sugarland. One of the streets was named Clinch Road, after his wife. He purchased land near what became Dulles Airport, hoping that it would be worth something in the future. He built a house on Swinks Mill Road, moving into it with Marion in 1957. Marion died in 1968. Mark later married Mildred Parker Mackall Pickett, the mother of Henry and Douglass Mackall. (Julie Merrell Harris.)

Peter Nordlie

When Peter was a year old, in 1931, his parents, Leonard and Emma Bates Nordlie, purchased a chicken farm on Balls Hill Road that included a Sears & Roebuck house. Leonard worked for the government. Peter and his brother Rolf attended the Franklin Sherman School and enjoyed riding horses. Their property was taken through eminent domain in 1956 for construction of the Capital Beltway. (Dariel Knauss Van Wagoner.)

Billy Jones

Jones grew up in the Langley area of McLean and attended the Franklin Sherman School. In 1990, he chaired the McLean Settlers Clan Reunion, an event held at the Pavilions of Turkey Run for those who lived in McLean prior to 1955. Over 1,000 people attended. Jones (left) is shown talking with longtime residents Peggy Morris, Henry Mackall (second from right), and Rolph Nordlie. (Dariel Knauss Van Wagoner.)

Clive DuVal 2nd

DuVal, a Yale Law School graduate, was a lieutenant commander in the Navy during World War II, serving with the 16th Air Group aboard the USS *Lexington* in the Pacific. He moved with his wife, Sue, and their three children to the Northern Virginia area in 1951 to take the position of special assistant to the under secretary of the Army. In 1953, the DuVals purchased 52 acres from the estate of Calder Smoot that included the historic mansion house known as Salona. Before moving into the house, they undertook a significant restoration project maintaining its historic accuracy. They immersed themselves in affairs of the community and opened Salona for social, political, and community activities. Sue, an artist, became involved with the Emerson Gallery (later the McLean Project for the Arts). Clive joined the McLean Citizens Association. As an ardent proponent of environmental conservation, he was a leading force in defeating the 47-acre Merrywood estate from being developed into high-rise apartments along the banks of the Potomac. This was the impetus for his career in the Virginia House of Delegates (1965–1971) and Virginia State Senate (1971–1991). Through eminent domain, three acres were taken from their property for widening Chain Bridge Road, which was renamed Dolley Madison Boulevard in 1962.

In an effort to preserve historic Salona, the DuVals entered into an agreement with the Fairfax County Board of Supervisors in 1971 that established a permanent easement for the house and surrounding eight acres. This included a renewable 10-year, no-development easement of the remaining acres. Salona is listed in the National Register of Historic Places, the Virginia Landmarks Register, as well as the Inventory of Historic Sites in Fairfax County. Sue died in 1997. In her memory, the DuVal family funded an addition to the McLean Community Center for use as exhibit space and art classrooms, named the Susan B. DuVal Studio. Clive died in 2002. His heirs executed a perpetual conservation easement with the Fairfax County Park Authority in 2005, granting approximately 41.5 acres of the Salona property for use as parkland. The existing easement surrounding the house remained and was not part of the park easement. The DuVal family is seen here around 1957 on the grounds in front of Salona. They are, from left to right, Daniel, Lyn, Clive 2nd, Sue, David, and Clive III. (DuVal family.)

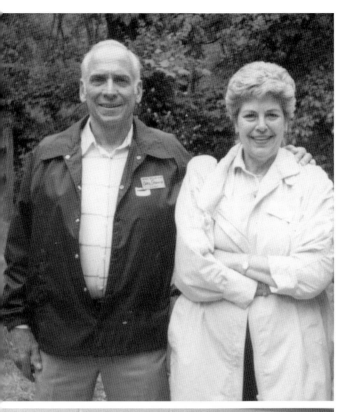

Carl Schmidt
As a youth, Carl Schmidt worked at the Great Falls Inn, a family business established by his grandparents Carl and Isabella Blaubock around 1906. Carl's parents, Albert and Isabelle Schmidt, later took over the business. Carl purchased the Esso filling station at Spring Hill Road and Leesburg Pike in 1955 and, from there, operated a successful towing business. Here, Carl poses with his wife, Elizabeth. (Dariel Knauss Van Wagoner.)

Dave Shonerd
The Shonerd family moved into a house on Waverly Way at Chain Bridge Road in 1934. The grounds eventually included a three-hole golf course, tennis court, apple orchard, and goldfish pond. They raised chickens and sold eggs. Dave Shonerd graduated from the Naval Academy in 1942 and spent most of World War II in the South Pacific. He is shown speaking before the McLean Historical Society. (Carole Herrick.)

Julia Snyder
Julia and her husband, Fred, lived on Ingleside Avenue where the Dolley Madison Library stands today. She was part of the Ladies Auxiliary that supported the McLean Volunteer Fire Department and was their principal cook. Julia also ran bake sales for the Firemen's Carnival and volunteered as a bus driver for the Fairfax County School system. Here, she stands in front of her bus. (Libby Trammell.)

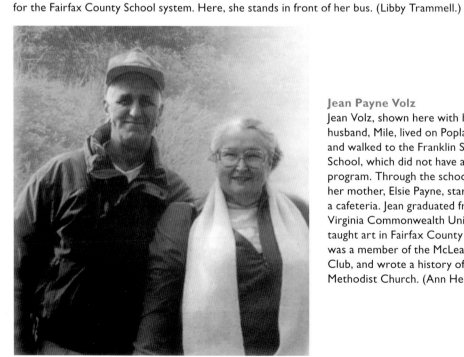

Jean Payne Volz
Jean Volz, shown here with her husband, Mile, lived on Poplar Street and walked to the Franklin Sherman School, which did not have a lunch program. Through the school's PTA, her mother, Elsie Payne, started a cafeteria. Jean graduated from Virginia Commonwealth University, taught art in Fairfax County schools, was a member of the McLean Art Club, and wrote a history of Trinity Methodist Church. (Ann Hennings.)

William Stalcup

William was one of six children born to Inez and Guy Stalcup. He grew up working in their general store on Kirby Road, which his mother continued operating after his father's death in 1936. Before William was old enough to obtain a driver's license, he would take a Model T or Model A truck into the District and bring supplies back to the store. The family had about 25 acres along Park Street that they farmed. Their produce was sold in the store and by William at a stand in the District. William tired of this operation and sold the stand to a farmer, who then sold Stalcup produce. Inez gave each of her children a few acres from the farm when they became adults. After returning from World War II service in Europe, William married Caroline Humphry. They built a house on his acreage and raised eight children. At one time, communities had their own baseball teams, and William played on one. But his passion was duckpin bowling. In 1956, he was the number one duckpin bowler in Washington.

In 1958, William opened and operated Stalcup's Furniture in Falls Church, but he continued to farm. He would begin the day working on the farm, go to the store, and, after dinner, continue farming operations. He bought a strip of property on Old Dominion Drive near the Kirby Road bridge and opened a vegetable stand, which his retired brother Sam operated. Today, this strip is adjacent to the Chesterbrook Shopping Center. As his children grew older, they became active in maintaining the farming tradition. A produce stand went up in front of their house. The family went into the Christmas-tree business and began selling trees outside the Farmer's Market Building on Twenty-first Street. This led to selling Christmas trees at the stand on Old Dominion Drive. Sons Billy and George worked the District stand, and sons Philip and Sam took care of the Virginia operations. Christmas trees were also sold at Stalcup's Furniture. In 1979, William grew pumpkins on several plots of land throughout Chesterbrook. One year he decided to hold a pumpkin hunt and give away pumpkins to families in Chesterbrook. This turned into an annual event, Charlie Brown's Great Pumpkin Hunt. People of all ages attended. There was music, food, and prizes. William loved the pumpkin hunt, and he is shown at the 1983 event. (Stalcup family.)

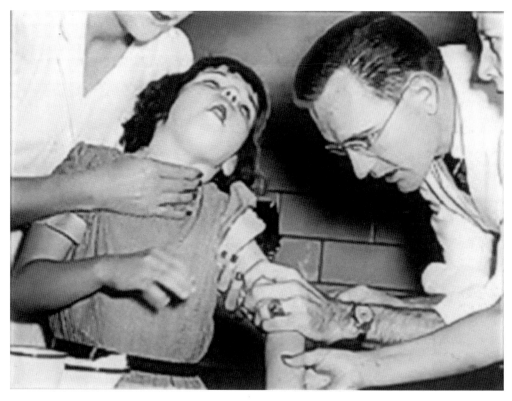

Dr. Richard Mulvaney
On April 26, 1954, Dr. Mulvaney, McLean's first medical doctor, inoculated students at the Franklin Sherman School with the Salk polio vaccine. The school was the stage for the nation's first field trial of Jonas Salk's polio vaccine. The children who participated became known as "polio pioneers." Dr. Mulvaney is shown giving seven-year-old Patricia Abott her vaccination. (March of Dimes.)

Wallace Carper
Wallace Carper and his wife, Katherine, owned a large dairy farm that became Greenway Heights. He was a member of the Maryland-Virginia Milk Producers Association. Carper was elected to the Fairfax County Board of Supervisors in 1932, serving for 24 years until he was defeated in 1955. For the last 15 years of his tenure, he led the county as chairman of the board. (*Fairfax County in Virginia.*)

Martha Ulfelder Seeley
Martha Seeley grew up in Mexico City and at Maplewood, a large dairy farm located on Chain Bridge Road between McLean and Tysons Corner. After marrying Rudolph Seeley, she returned to Maplewood and raised three children. The farm was later combined with other land holdings and developed as West*Gate and West*Park office parks; the historic Maplewood house was demolished in 1970. Martha, interested in the arts, had a particular interest in pottery. Along with her husband, she supported Wolf Trap Farm Park, the Fairfax Symphony, and the McLean Orchestra. She was a founding member of the McLean Art Club and served on the board of the McLean Project for the Arts. (Dariel Knauss Van Wagoner.)

Mary Elizabeth Seip

Mary Elizabeth, shown with Pat Mayer of Great Falls (right), married Buddy Rector in 1950, whose family was in the greenhouse/nursery business. Buddy died suddenly three years later. Frances Rector Sparger opened a florist shop, and Mary Elizabeth did the bookkeeping. She later married Leonard Seip and moved into the West McLean area. Mary Elizabeth has been active with the Daughters of the American Revolution and Sharon Masonic Lodge 327. (Carole Herrick.)

Warren Gray

Gray, along with his son Fred, built their family's home on Old Chesterbrook Road near Pimmit Run. When the CIA moved its headquarters to McLean, his services as a wallpaper hanger were in great demand. He was friends with Adeline and Harry Hill, whose farm was located along Kirby Road. Here, Warren Gray poses with Lady, the horse of the Hills granddaughter Janet Beall. (Janet Beall.)

G.L. "Jerry" Hennings

At one time, McLean was known as "gasoline alley." Jerry Hennings, who grew up on Curran Street, opened Hennings Service Station, selling Sinclair gasoline, in 1956 at the triangle formed at Chain Bridge and Old Chain Bridge Roads. He was interested in electronics and worked with Don and Dave Schlegel at McLean Electronics. Later, he operated his own business, Sheffield Electronics, in Annandale, before working for the Fairfax County School System as a field supervisor for electronic equipment, retiring in 2003. During 1954–1955, Hennings was employed by the Army at the National Guard site, where the CIA is today. The following year, he saw duty at the Nike missile site on Utterback Road in Great Falls. The McLean Volunteer Fire Department was a big part of his life; Hennings became a life member in 1980. (Ann Hennings.)

Edwin B. Lawless Jr.
Lawless had been in the construction business with his brother Pete for over a year before moving to McLean with his family in 1947. Through their company, Providence Construction, they built Providence Forest, the McLean Fire Station in 1948, and many custom homes throughout the area. Lawless was treasurer of the McLean Volunteer Fire Department for 19 years. (Barney Lawless.)

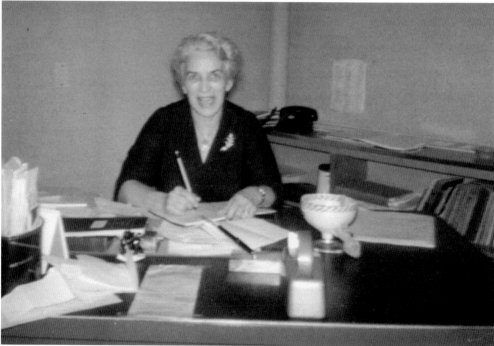

Agnes Lawless
A teacher at the Franklin Sherman School from 1945 to 1955, Lawless was at the Oakton School for a year before accepting a position as the first principal of the new Kent Gardens School. She served there from 1957 to 1967. After retiring, she logged over 3,000 hours of volunteer work at the Fairfax Hospital. Lawless is shown at her desk in her Kent Gardens office in 1957. (Barney Lawless.)

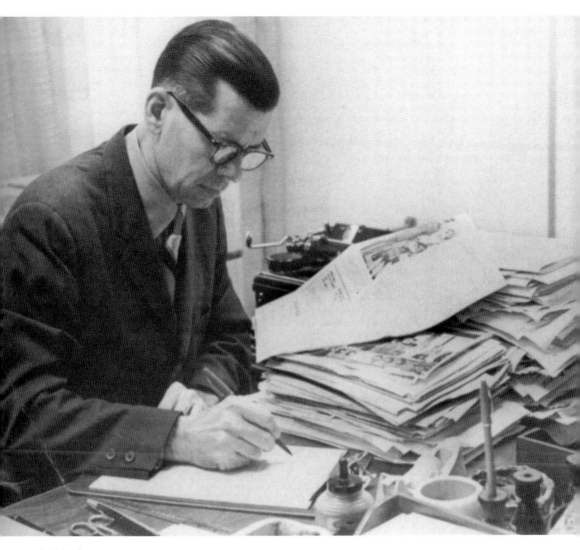

Bill Elvin

In 1956, Elvin left the *Washington Star* and purchased the *Providence Journal*, a weekly newspaper published by Richard Smith beginning on April 27, 1944. This was a risky venture. Newspaper journalists considered themselves reporters and viewed McLean as a small farming community with little to write about. Elvin correctly foresaw that the population of McLean and Fairfax County would grow and that his paper would have much to report. Renamed the *McLean Providence Journal*, Elvin's paper was the heartbeat of the community for three decades. It was sold to David Dear, president of Dear Communications, in 1986. Elvin served in Europe during World War II, but talked little about his war experiences or that he received a Silver Star for battlefield valor. He is seen here in 1959, working on a story. (Jan Elvin.)

Stuart Robeson

During World War II, at age 36, Robeson was drafted into the Navy. He was a lawyer, married with two children. He served in the Pacific theater as a lieutenant junior grade in the legal office. In 1948, he purchased Chestnut Hill. The family renovated the house, renaming it Merryhill. Stuart (right) is seen on an unidentified island in the Pacific during the war. (Palmer Robeson.)

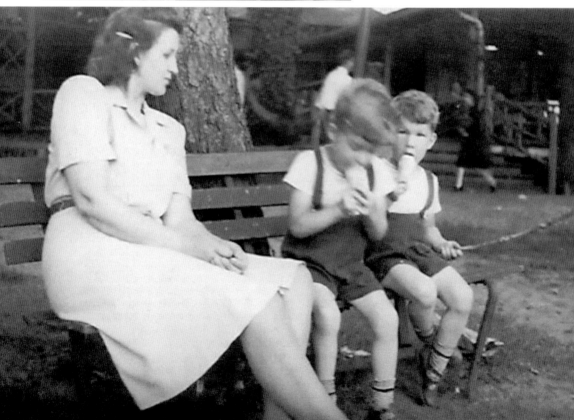

Mary Leigh Robeson

Before marrying Stuart Robeson, Mary was a teacher. She graduated from high school in 1926 at age 15 and, two years later, received her teaching certificate from Virginia State Teacher's College in Harrisonburg. Mary began teaching at the Franklin Sherman School two months later, at age 17. She is shown on a family outing around 1945 with her first two children, James (center) and Stuart Jr. (Palmer Robeson.)

William Wheat

"Willie" Wheat grew up on Balls Hill Road. He graduated from Fairfax High in 1942 and entered the Army as a paratrooper in the 11th Airborne Division. After the war, he married Dordy Montgomery and became active with the McLean Volunteer Fire Department. Willie Wheat was at the Battle of Luzon and is part of a documentary about the event sponsored by the History Channel in England. (Mike Wheat.)

Kathryn Compton Laughlin

"Kitty" Laughlin continued the real estate operations of the Laughlin family after the death of her husband, William Laughlin, in 1948. She had a six-month-old child at that time, William "Kip" Laughlin. Both Mrs. William H. Laughlin Realtor and the insurance agency owned by Bess Wells Hall operated inside the Laughlin farmhouse ("Blue House") at Chain Bridge Road and Old Dominion Drive. (Kip Laughlin.)

Julia Sterling Knauss

Julia and Norman Knauss moved to McLean in 1919, eventually locating in Walter Heights, a community of Sears & Roebuck houses. Julia (right) had been a prize-winning entertainer when recitations were the vogue. She was enthusiastic about helping the McLean Summer Theatre, loaning furniture and clothing from her collection of antique clothes for their use. After her husband's death, Julia Knauss worked in the McLean Bowling Alley, owned and operated by Annabelle and Mark Rhinehart. Julia bowled on a team until she was into her nineties. At the McLean Settlers Clan Reunion, held at the Pavilions of Turkey Run (Claude Moore Colonial Farm) in 1990, a sign was made for residents of Marion Avenue. Julia stands at center in the below photograph with her four daughters, left to right, Sylvia, Dariel, Julia, and Annabelle. (Both, Dariel Knauss Van Wagoner.)

Dr. Vincent Joseph Dardin
Dr. Dardin was a pathologist and professor at Georgetown University, where he taught in the medical and dental schools and served on the staff of the university's pathology department. He lived on Leesburg Pike, where the Sheridan Hotel is today, with his wife, Josephine, and their three children. Dr. Dardin is shown in 1942 at Kenilworth Farm, where he kept his horse. (Joan Smith.)

Mary Jackson Loftus Craighill
After marrying Bowdoin Craighill in 1952, Mary, the daughter of Irene and Justice Robert Jackson, opened a studio for modern dance in their home on Waverly Way. A career unfolded for Mary when she formed the Mary Craighill Dance Company and, later, in 1962, founded the St. Mark's Dance Company. Craighill (right) is shown working with students of the St. Mark's Junior Company at her studio. (Rosetta "Rosie" Brooks.)

Beverly Mosby Coleman
Coleman, a grandson of Col. John Singleton Mosby, was a 1922 graduate of the US Naval Academy. He retired in 1958 as a rear admiral and continued practicing law. He is shown holding the cane given to his grandfather by former drummer boy and prisoner Jimmy Daley, who was pardoned from execution by Colonel Mosby during the "Death Lottery" at Rectortown, Virginia, in 1864. (Tom Evans.)

Earl Sanders
Earl and Bessie Sanders lived on Elm Street near Storm's Store, where they raised three children, Vernon, Dorothy, and Mary. Earl was a member of Sharon Lodge No. 327 and a life member of the McLean Volunteer Fire Department. Their house was later moved to another location on Elm Street near Ingleside Avenue. Earl and Bessie are shown on their wedding day, April 8, 1914. (*McLean Remembers Again.*)

CHAPTER FOUR

Preserving a Community
1960–Forward

In 1961, the first employees reported for work at the campus-like CIA headquarters, located on Chain Bridge Road near Georgetown Pike. It was half the size of the Pentagon. With 10,000 employees, new roads had to be built or old roads altered to accommodate the increase in vehicular traffic. For instance, Chain Bridge Road (Route 123) was widened to the east from the entrance of the CIA to connect with the George Washington Memorial Parkway. Dolley Madison Boulevard, a widening of Chain Bridge Road and a newly created road that bypassed McLean's business district, opened in 1962. The George Washington Memorial Parkway was extended from the Arlington County line to connect with the Capital Beltway (I-495) at the Cabin John Bridge (renamed the American Legion Bridge); dedication ceremonies were held on December 31, 1962. Dulles International Airport opened in 1961. McLean was positioned for growth. But the boom began in 1968 at a nondescript intersection just down the road from McLean known as Tysons Corner. A "sleeping giant" awoke at that location, a spot that few had given much attention to, and McLean suddenly found itself overshadowed by construction of the Tysons Corner Shopping Center. Today, Tysons Corner is one of the largest office and retail centers in the United States.

Tysons Corner continues to grow, yet, the village of McLean has undergone little change since the 1960s. Clearly, the windmills, farms, and orchards are gone, and notable dairy farms such as Maplewood, Sharon, Storm, Ballantrae, Spring Hill, and Kenilworth have been replaced with subdivisions and homes on a grand scale. Additional schools have been built, and the unincorporated village of McLean supports two public high schools, McLean High School (1955) and Langley High School (1964). With all of the growth, the footprint of downtown McLean remains very rural. One has to wonder about McLean's future. With the urbanization and continued expansion of Tysons Corner, and the opening of the Washington Metro's Silver Line, will the village of McLean go the way of Lewinsville or Langley? Hopefully, this will not be the case, and McLean's pride and tremendous community spirit will prevail, so that McLean will not lose its identity and get gobbled up in the enthusiasm of progress.

Robert and Ethel Kennedy

In 1957, Bobby and Ethel Kennedy moved into Hickory Hill with their five children at that time, shown from left to right, Joe, David, Bobby Jr., Kathleen, and Courtney. They surrounded themselves with accomplished people from all walks of life and always had a steady stream of friends, colleagues, and dignitaries at the house. Theirs was an active lifestyle. From the very beginning of their residency, there was constant activity, whether it was tennis matches, touch football games, pet shows, political events, fundraisers for charitable causes, or entertaining heads of state and other government officials. Hickory Hill became a household word and, in a sense, the Kennedys put McLean "on the map." Bobby's brother John was sworn in as president of the United States on January 20, 1961, and Bobby was appointed attorney general. He was a close advisor to the president and was involved in many foreign-policy discussions. Ethel and Bobby were at Hickory Hill on November 22, 1963, when President Kennedy was assassinated. The FBI, Secret Service, Fairfax County Police, and reporters surrounded the estate in the belief that the shooting was part of a larger conspiracy, with Bobby as the next target.

On August 25, 1964, less than a year after his brother's death, Bobby announced his candidacy for the US Senate representing New York. He then resigned his position as attorney general. As attorney general, Bobby initiated a campaign against organized crime, sought to secure African Americans the right to vote, and devoted energy to civil rights for all Americans. *Brown vs. Board of Education* was the law of the land, and he was determined to enforce it. In September 1962, he ordered US Marshals and troops to Oxford, Mississippi, to make sure James Meredith was admitted to the University of Mississippi. Kennedy won the senate election and later sought a 1968 presidential bid. After winning the California presidential primary, he was assassinated in Los Angeles on June 5, 1968. At that time, the Kennedys had 10 children, and Ethel was pregnant with their 11th. She continued to reside at Hickory Hill and hosted fundraising events. As the children grew older and went their own way, Hickory Hill became too large. Ethel eventually sold it to Ashley and Alan Dabbiere in 2009. (Paul Schutzer.)

Winslow Hatch

After retiring from the federal government in 1971, Hatch promoted McLean's history. He enjoyed providing education through on-site research. Many people trooped through fields and woods with him, looking at ruins of mills, graveyards, and houses. Winslow was an early president of McLean Chapter AARP 839. After his death, the chapter sponsored a roadside marker that was placed on the grounds of his historic home, Benvenue. (*Northern Virginia Heritage.*)

Frank Gapp

Gapp worked for 30 years as a news editor for *U.S. News and World Report.* He was interested in history, and, after retirement, he researched and wrote about events and institutions that influenced the McLean area, particularly the Lewinsville Presbyterian Church, of which he was a member. Gapp authored *The Commodore and the Whale,* an account of the tumultuous life of Commodore Thomas AP Catesby Jones. (Lewinsville Presbyterian Church.)

Sam Stalcup

Stalcup retired from government service about 1960. It was not long before he began operating a produce stand on Old Dominion Drive in a field next to the AMOCO service station at Kirby Road. He understood the business, because he had been involved with his brother William's family in selling produce at the Western Market, a farmer's market at the corner of Twenty-first and K Streets in the District. To stock his stand, Sam (left) purchased vegetables that William and his family had grown. Soon after he opened, the Chesterbrook Shopping Center was built on adjacent property, and his business exploded. In later years, Sam's son Justin took on a significant role and eventually took over the business. In the below photograph, Justin is wearing an apron, and Sam is by the scales, wearing a hat. (Stalcup family.)

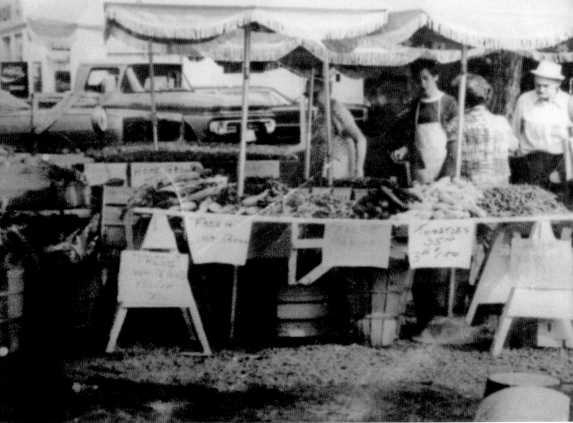

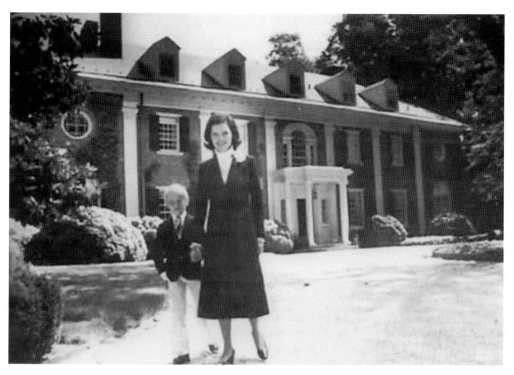

Nancy Dickerson

A noted pioneering radio and television newswoman who later became an independent producer of documentaries, Nancy married C. Wyatt Dickerson in 1962, and they purchased Merrywood in 1964. She was the first woman to break into the all-male Washington television news corps and the only woman to cover the significant events of the 1960s. She is pictured outside Merrywood with her youngest son, John. (Harry Sounds.)

Roger Mudd

Mudd helped shape television news at CBS, NBC, Public Broadcasting, and the History Channel. He is a director emeritus of the Montpelier Foundation, trustee of the National Portrait Gallery, recipient of five Emmys, and author of *The Place to Be: Washington, CBS, and the Glory Days of Television News.* Mudd resides in a historic home known as Elmwood. (McLean Community Center.)

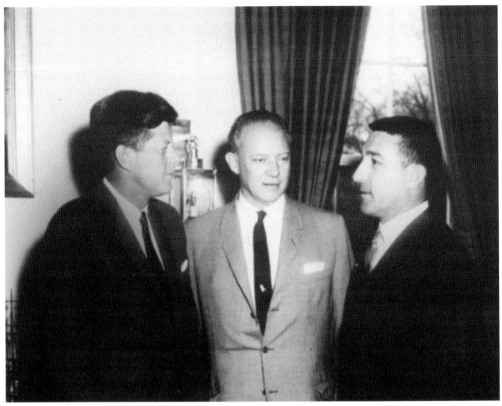

Stewart Udall

As secretary of the interior from 1961 to 1969, Udall helped McLean citizens during the battle over the Merrywood property, which had been rezoned for high-rise apartments. He obtained federal funds to secure a conservation easement along the Potomac River, and the beauty of the Palisades was left undisturbed. He is shown here on the right, with President Kennedy (left) and Gov. Stephen McNichols of Colorado. (John F. Kennedy Presidential Library and Museum.)

John Van Wagoner

Van Wagoner moved to McLean in 1950. He later married Dariel Knauss and started construction companies, including Prospect Industries and Insulated Building Systems. He joined the McLean Kiwanis, served on the Fairfax County Fire Appeals Board, and has been involved with the Washington National Cathedral for over 30 years. Following the 2011 earthquake, Van Wagoner has been active in raising funds for the cathedral's restoration. (John Van Wagoner.)

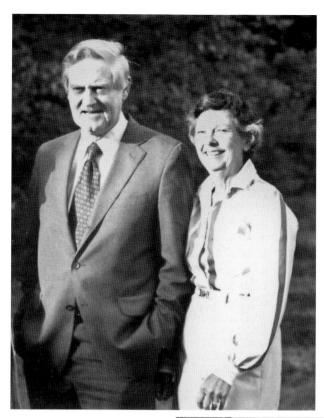

Linwood Holton
Holton was Virginia's governor from 1970 to 1974. After leaving office, he served as assistant secretary of state for legislative affairs before resigning to once again practice law. He later served as president of the Center for Innovative Technology. Both Linwood and his wife, Jinks, actively participated in the community, particularly the McLean Project for the Arts, McLean Chamber Orchestra, and the early years of the McLean Community Center. (Nancy Falck.)

Vince Callahan
For 40 years (1968–2008), Vince Callahan served as a member of Virginia's House of Delegates. He represented the 34th District, which included McLean. During his tenure, he held many key positions, including chair of the Joint Legislative Audit and Review Commission, chair of the Joint House-Senate Republican Caucus, House Minority leader, and chair of the House Appropriations Committee. He owned Callahan Publications from 1957 to 2000. (Sorensen Institute.)

Harriett Bradley

A proposal to build high-rise apartments at Merrywood along the Potomac River was opposed by many citizens. This was the genesis of the Dranesville Independent Force, which nominated Bradley as an independent candidate for the board of supervisors in 1963 to protect the Potomac Palisades. She won the election. A citizen battle to save 336 acres of wilderness along the river called the Burling Tract happened while Bradley was supervisor. A special tax district was eventually created with voter approval. The land was not developed and, later, was named Scott's Run Nature Preserve. A McLean government center and police substation opened on Balls Hill Road on November 26, 1971. This photograph shows, from left to right, Chief William Durrer, Bradley, Captain John Wahl, and Dan Capper in front of the station, planting a tree donated by First Lady Pat Nixon. (Fairfax County Police Historical Association.)

Nancy Falck

Falck, a graduate of the College of William and Mary, was elected to the Fairfax County Board of Supervisors in 1979 representing the Dranesville District, serving two terms of four years each. She previously served on the Fairfax County School Board. After leaving office, Nancy and her husband, George, were active volunteers in the greater McLean community. Falck is shown here with Virginia governor John Dalton finalizing a McLean project. (Nancy Falck.)

George Lilly

Lilly, shown with Dranesville's supervisor, Nancy Falck, was twice chairman of the Fairfax County Planning Commission and fought to keep McLean from being absorbed by the expanding Tysons Corner. He served two years as president of the McLean Citizens Association, helped establish the McLean Citizens Foundation, was executive director of the McLean Revitalization Committee, and was instrumental in obtaining the land for the McLean Community Center. (Nancy Falck.)

93

John Shacochis
As president of the West Lewinsville–Rosemont Civic Association, Shacochis proposed incorporating the Lewinsville area and turning it into a township. This did not happen. He led a citizen fight for a park to be created, rather than a townhouse development, on the Hamel tract. That property is known today as Lewinsville Park. Shacochis was later elected to the Fairfax County Board of Supervisors, serving from 1976 to 1979. (Carole Herrick.)

Lilla Richards
Richards, a past president of the McLean Citizens Association and McLean Citizens Foundation, represented Dranesville District on the Fairfax County Board of Supervisors from 1988 to 1992. She was a member of George Mason University's board of visitors and was named Citizen of the Year by the McLean Citizens Association in 2006. McLean Project of the Arts honored Richards in 2014 for her efforts on behalf of the organization. (Merrily Pierce.)

Henry Clinton Mackall

Mackall attended the Franklin Sherman School in McLean and Episcopal High School in Alexandria. In 1945, he went into the Army and served in the post–World War II occupation of Japan. After returning, he attended the University of Virginia and graduated from its School of Law in 1952. He was an attorney in Fairfax County and served on the boards of numerous organizations. Mackall was passionate about history and his family's genealogy, evidenced by his participation in the Society of the Cincinnati. He was an officer for organizations such as the Historical Society of Fairfax County, the Jamestown Society, the Northern Virginia Association of Historians, the McLean Historical Society, and McLean & Great Falls Celebrate Virginia. He was a founding director of Chain Bridge Bank; the bank's boardroom is dedicated to his memory. (Chain Bridge Bank.)

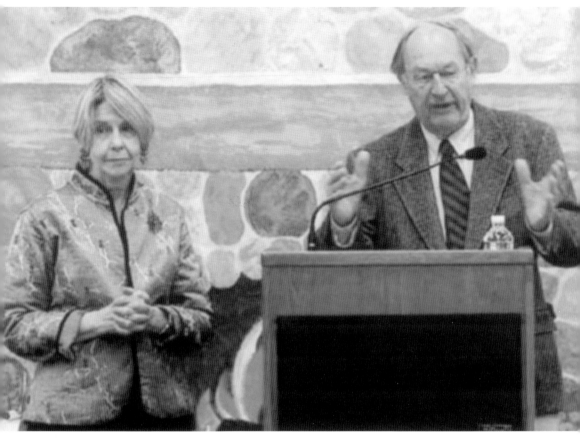

Douglass Sorrel Mackall III

The Mackall family history in the Langley area began in 1839, when Brook Mackall purchased 530 acres from Elizabeth Lee and heirs of her husband, Richard Bland Lee. Doug's father, Douglass Sorrel Mackall Jr., died suddenly in 1946. His mother, Mildred, then married Charles Pickett, and the family moved to Fairfax City. Doug Mackall graduated from the University of Virginia Law School and practiced law in Fairfax City with his brother, Henry, at their firm Mackall, Mackall & Gibb. Doug is a past president of the Historical Society of Fairfax County and a board member of the McLean Historical Society. Here, Doug Mackall speaks before Friends of the Virginia Room on October 24, 2010. Its president, Phylis Salak, stands next to him. (Bill Millhouser.)

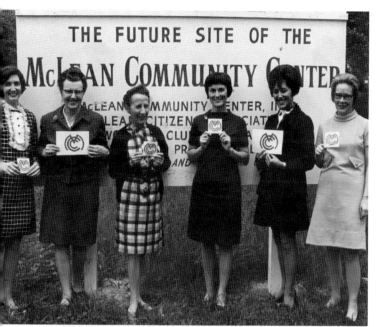

Diane Alden
Alden was a columnist for the *McLean Providence Journal*, secretary of the McLean Citizens Association, administrative assistant to state senator Clive DuVal 2nd, and board member of the McLean Community Center. After the Fairfax County Board of Supervisors agreed in 1969 to build a community center for McLean, Alden (far left) helped launch the fundraising effort for the facility with other volunteers. (McLean Community Center.)

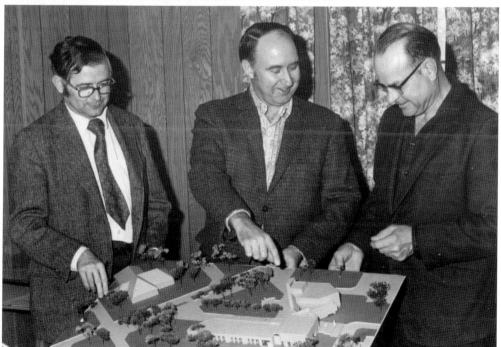

McLean Community Center Design
The architect firm Gwathmey-Duke was selected to design the McLean Community Center (MCC). The MCC governing board approved the plan on October 25, 1972. Shown looking over the model of a 20,000-square-foot, bi-level facility are, from left to right, Robert Alden, vice-chair of the governing board; a Fairfax County representative; and Max Hines, a member of the governing board. (McLean Community Center.)

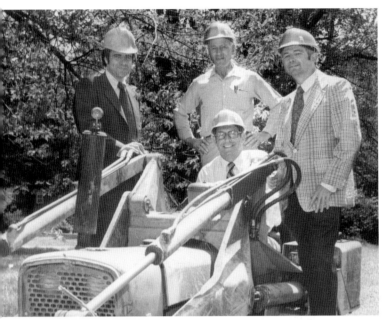

McLean Community Center Construction
In April, 1974 construction began on the McLean Community Center. At the controls of the bulldozer is Rufus Phillips, Fairfax County supervisor representing the Dranesville District. Standing behind him are, from left to right, Drew Valentine, treasurer of the center's governing board; Andre Bodor, contractor; and Robert Alden, chair of the center's governing board from 1973 to 1975. (McLean Community Center.)

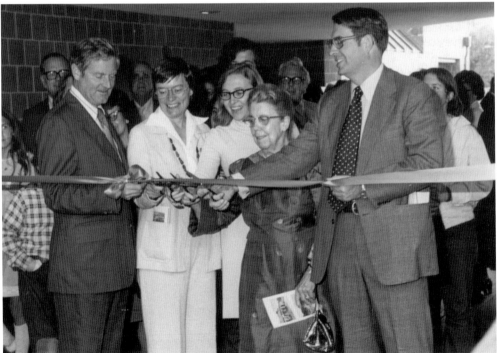

McLean Community Center Ribbon Cutting
The McLean Community Center opened on October 19, 1975, with a grand ribbon-cutting ceremony. Shown here are, from left to right, Linwood Holton, former governor of Virginia; Jean Packard, chair of Fairfax County Board of Supervisors; Joan DuBois, chair of McLean Community Center Governing Board; Charlotte Troughton Corner, first principal of Franklin Sherman School; and Rufus Philips, Dranesville's representative to the Fairfax County Board of Supervisors. (McLean Community Center.)

Page Shelp
The first executive director of the McLean Community Center was Page Shelp, who served the community in that capacity for 25 years, until retiring in 1999. During her tenure, the center physically tripled in size from its opening in 1975, and the programs went from the single digits to hundreds of activities, including McLean Day and the Fourth of July festivities. (McLean Community Center.)

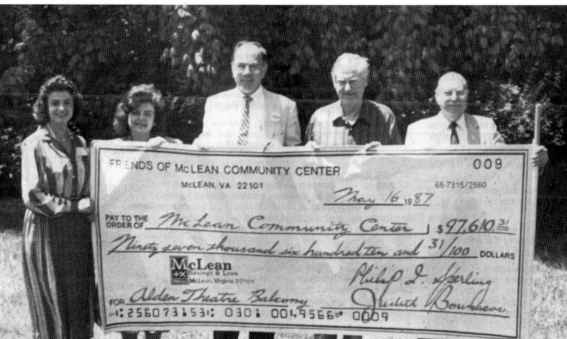

Friends of the McLean Community Center
In 1987, a balcony was added to the McLean Community Center's Alden Theatre. Funds were raised by Friends of the McLean Community Center. Shown here are, from left to right, Elaine Lailas, Judith Bounacos, Stan Richards, Gov. Linwood Holton, and Philip Sperling. (McLean Community Center.)

H. Gordon Randall

Randall's ambition was to be an actor. He did stunt work in early Western movies. His father disproved of Hollywood and persuaded Gordon to join the US Army. After retiring from the service as a colonel, he contributed his talent and enthusiasm to the betterment of the McLean community through volunteerism. At one time, he was commander of McLean's American Legion Post 270. Randall was elected to the governing board of the McLean Community Center and later served on the board of Friends of the McLean Community Center. He organized volunteers and was constantly recruiting for every major event. Because of his commitment to the community, the McLean Community Center established the annual H. Gordon Randall award after his death to honor outstanding volunteers in the community. (McLean Community Center.)

James Macdonald
The McLean Community Center established the annual James C. Macdonald Arts Scholarship Fund to honor James Macdonald, the center's first deputy director in charge of theater and youth programs. Macdonald died prematurely in 1984. This 1976 photograph shows the center's executive director Page Shelp (left), Macdonald, and administrative assistant Mary Anne Hampton enjoying outside activities on the grounds of the center. (McLean Community Center.)

Marie Swinson
For many years, Marie Swinson (center) was the music director at the Lewinsville Presbyterian Church while also championing the causes of senior citizens. She was highly regarded throughout McLean and Fairfax County as a pioneering advocate for the elderly. Swinson served on the governing board of the McLean Community Center and, when the facility opened in 1975, a room was named in her honor. (McLean Community Center.)

Dingwall Fleary
Fleary became the music director and conductor of the McLean Chamber Orchestra with its formation in 1972. It is known today as the McLean Symphony. Fleary has provided quality music and educational programs for McLean. He also conducts the Reston Community Orchestra. He served as music director of the International Children's Festival at Wolf Trap Farm Park and was a member of the Virginia Commission for the Arts. (John Holley.)

Edith Wilson
After retiring as a teacher at the Franklin Sherman Elementary School, Wilson continued serving McLean as a leader in many organizations, such as the McLean Citizens Association, McLean Woman's Club, and McLean Chapter AARP 839. She is pictured receiving a Fairfax County award of appreciation at the county's annual Senior Recognition Ceremony in 2003 for her commitment to the welfare of seniors. (Carole Herrick.)

Charles and Lynda Johnson Robb
After their White House wedding in 1967, Chuck and Lynda Robb chose to live in McLean, building a beautiful home overlooking the Potomac River. In 1977, Chuck was elected Virginia's lieutenant governor, and he became the 64th governor of the commonwealth in 1982. He served two terms as a US senator representing Virginia (1989–2001). After retiring, Chuck, a Marine Corps veteran, served on the board of visitors at the US Naval Academy, began teaching law at George Mason University, and cochaired the Iraq Intelligence Commission. Lynda, a former chairman of Reading is Fundamental, serves on the board of directors for the Lyndon Baines Johnson Foundation and the Lady Bird Wildflower Center. The couple has three daughters and three grandchildren. (McLean Project for the Arts.)

Richard Poole Subdivisions that began to be developed in the McLean area after World War II were built on former farmland; thus, there were few trees. The McLean Citizens Association established a trees committee in 1980, with Richard Poole as its chair. The proceeds from the committee's recycling of newspapers and magazines went toward planting trees and shrubs throughout the McLean area. (Merrily Pierce.)

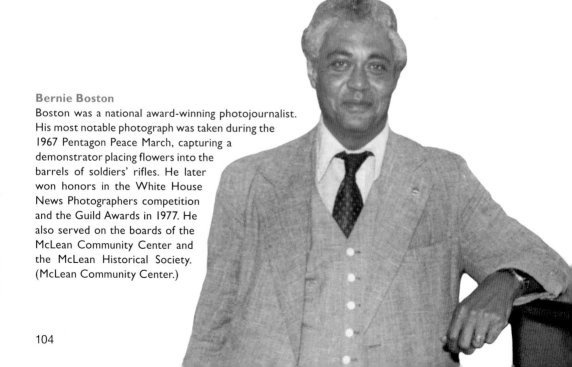

Bernie Boston Boston was a national award-winning photojournalist. His most notable photograph was taken during the 1967 Pentagon Peace March, capturing a demonstrator placing flowers into the barrels of soldiers' rifles. He later won honors in the White House News Photographers competition and the Guild Awards in 1977. He also served on the boards of the McLean Community Center and the McLean Historical Society. (McLean Community Center.)

Karen Bassford
The first Fairfax County police officer to be killed in the line of duty was Officer Karen Bassford, who worked at the McLean District Station. On July 27, 1977, the station received a call of a burglary in progress. In responding, Bassford's cruiser struck a utility pole on Gallows Road. Thrown from her vehicle, Bassford died shortly after. The call turned out to be unfounded. (Fairfax County Police Historical Association.)

Minerva Andrews
Minerva, one of the first women to graduate from the University of Virginia Law School, married Bob Andrews in 1950. Bob later served in Virginia's House of Delegates. Minerva practiced law until retiring from McGuire, Woods, Battle & Booth in 1992. She served on the board of the McLean Citizens Association and was the Fairfax Federation of Citizens Association's citizen of the year in 1997. (Carole Herrick.)

Claiborne Morton

"Buck" Morton, who served in the Coast Guard, was a businessman. He opened stationery stores in Vienna and McLean named The Secretary's Friend and was a president of the McLean Business and Professional Organization and area Jaycees. Morton was active in Republican politics. He died unexpectedly from cancer during his 1983 campaign to unseat Clive DuVal 2nd and represent the 32nd district in Virginia's General Assembly. (Anne Morton Vandemark.)

Anne Morton Vandemark

Vandemark taught business and chaired the Business Education Department at Langley High School for 33 years. In 1985, she was named Virginia Business Teacher of the Year. She authored *The Secretary's Friend*, a guide to managing office problems, and wrote fashion articles for local publications. She is a past president of the McLean Business and Professional Association and a board member of the Kennedy Center. (Anne Morton Vandemark.)

Evelyn Fox
In 1979, Fox began working at the McLean Community Center as youth activities director. After retiring, she served on the center's governing board, eventually becoming chair. She is the recipient of many accolades, including the H. Gordon Randall Award, Friend in Deed, and the Distinguished Service Award from the Fairfax County History Commission for her role in writing *HiStory*, a play about early McLean. (McLean Community Center.)

Wanda Hill
A former music teacher at the Potomac School, Hill spent six years on the McLean Community Center's governing board and is a past chair. She also served on the board of Friends of the McLean Community Center, McLean Community Foundation, McLean Chamber Orchestra, and many schools, such as Groton. Hill founded Project Match in 1980 to help minority students in the Washington area attend boarding schools. (Wanda Hill.)

Mable and Myra Coates
Mable and Myra are mother and daughter, respectively. Over the years, they volunteered for various events sponsored by the McLean Community Center and, as a team, received the H. Gordon Randall Outstanding Volunteer Award in 2009. At one time, Mable drove a school bus. She was highly regarded by the students she transported, who, as adults, speak of her today with admiration and respect. (McLean Community Center.)

Pamela and David Danner
Both of the Danners have a business in McLean. Pamela heads a law practice, and David is president of IDEAMATICS, a software development company. Besides raising three daughters, they contribute to the community through organizations, including the McLean Community Center, McLean Rotary Club, McLean Orchestra, and McLean Community Foundation. Pamela served on the Fairfax County Water Authority Board and Tysons Corner Land Use Task Force. (David Danner.)

Fred Talbot
As a right-handed pitcher, Talbot had an American League baseball career that spanned eight years. He grew up in McLean and graduated from Fairfax High School. Talbot began pitching for the Chicago White Sox in 1963, followed by stints for the New York Yankees, Seattle Pilots, Kansas City Athletics, and Oakland Athletics, his last team. He retired on June 14, 1970. (The Topps Company, Inc.)

Charles Wissler
Dr. Wissler came to McLean in 1955 to practice dentistry, following Dr. Jerry O'Meara, who left the area. Wissler moved into the new McLean Shopping Center, owned by O.V. Carper, where he practiced until 1964, when he relocated into his own office on Balls Hill Road. He practiced there until he retired in 2007. Wissler enjoyed gardening and often shared fresh produce with his patients. (N. Lou Wissler.)

Adele Lebowitz

Adele and Mortimer Lebowitz, the founder of Morton's Department Stores in 1933, purchased property in 1952 along Georgetown Pike in the Langley area of McLean. They championed civil rights and justice for all. After Mortimer's death in 1997, Adele gave 18 acres to the Fairfax County Park Authority to build Clemyjontri Park, a playground with specialized equipment for children of all abilities to enjoy. (Fairfax County Park Authority.)

Janie and Bill Strauss

The Strausses enjoyed leisurely outings together. Janie, once a teacher and former president of the Franklin Sherman PTA, has served on the Fairfax County School Board from 1991 to the present. Bill was a cofounder and director of the satirical theater group known as the Capitol Steps and was cofounder of the Cappies, a theater program for high school students. (Beverly Crawford.)

Sonja Duffin Hurlbutt
Sonja Hurlbutt grew up in McLean when the Fairfax County Public School system was segregated. She attended schools at Odrick's Corner, Louise Archer, and Luther Jackson. After graduation, she had a career with the Hot Shoppes organization. Hurlbutt enjoys history, particularly the Civil War. She provides living history demonstrations for the Fairfax Rifles and is a member of the Bull Run Civil War Round Table. (Sonja Duffin Hurlbutt.)

Joan and Freeborn "Garry" Jewett
The Jewetts moved into Valley Farm, their home on Lewinsville Road, in 1960. They involved themselves with Neighbors for a Better Community to further integration throughout McLean. When Pleasant Grove Church was to be demolished in 1981, the Jewetts, Frances Moore, and others organized Friends of Pleasant Grove and saved the church. They are shown at a Pleasant Grove Christmas caroling party. (Carole Herrick.)

Marvin Quinn

Quinn, who served as a Navy radio operator in the Pacific during World War II, retired from the Veterans Administration. With his wife, Betty, he is active in AARP and the National Active and Retired Federal Employees (NARFE). Marvin does social work by visiting seniors who remain in their homes. For several years, he has been third vice-commander of American Legion Post 270. He is shown at McLean Day, offering American flags. (McLean Community Center.)

Robert Rosenbaum

Bob Rosenbaum was a first lieutenant in the counterintelligence division of the Army after graduating from Hampden-Sydney College. His commitment to the community is extensive, including the McLean Citizens Foundation, Friends of the McLean Community Center, McLean Youth, American Legion, and McLean Rotary Club. Known as the "Piano Man," Rosenbaum plays weekly at Lewinsville Day Health Care Center and at other senior facilities in Fairfax County. (Carole Herrick.)

Bobbie Kilberg

Kilberg, shown with her husband, Bill, is an attorney, mother of five, and grandmother of eight. She has been president and CEO of the Northern Virginia Technology Council since September 1998. Earlier, she was a senior staff member to Presidents Richard Nixon, Gerald Ford, and George H.W. Bush. Because of her expertise in the business community, President George W. Bush appointed Kilberg to the President's Council of Advisors on Science and Technology in 2001. In 2009, *Washingtonian* magazine named her Business Leader of the Year. In 2013, she was inducted into the Washington Business Hall of Fame. Her service on boards of directors include the governing boards of the University of Virginia, George Washington University, public television station WETA, The Potomac School, the Wolf Trap Foundation for the Performing Arts, and the Holocaust Memorial Council. (Bobbie Kilberg.)

Harold Skean

After retiring from the State Department, Harold Skean and his wife, Jane, spent time enriching the lives of seniors. They did volunteer work with Meals on Wheels, Powhatan Nursing Home, Lewinsville Senior Center, and he portrayed Santa Claus at senior facilities. They were active in NARFE and were founding members of McLean Chapter AARP 839. Here, Harold presents Yvonne Teweles an award recognizing her outstanding service to AARP. (Carole Herrick.)

Patty Wyne

Wyne, an advocate for seniors, serves as president of the Northern Virginia 55+ Club, is a past president of McLean Chapter AARP 839, and a board member of the Lewinsville Senior Council. She volunteers at the Lewinsville Senior Center, Lewinsville Day Health Care Center, and Powhatan Nursing Home. Wyne (center) is shown with Betty Sprouse (left) and Brenda Ryan, assistant director at the Lewinsville Senior Center. (Carole Herrick.)

Alice Starr
Starr was vice president of WEST*GROUP for 16 years and a past president of the McLean Chamber of Commerce and McLean Project for the Arts (MPA). She serves on the boards of Claude Moore Colonial Farm and the Fairfax County Public Library Foundation and is involved with Jill's House. Starr (center) and Gerry Brock (right) present a bouquet to Mary Bowman for her MPA support. (MPA.)

Geraldine Brock
The late Gerry Brock was the first executive director of the McLean Project for the Arts (MPA), after serving a number of years as president. The MPA is a nonprofit visual-arts program that offers exhibit space for contemporary artists, housed inside the McLean Community Center. Brock (right) is shown at an MPA reception with Lisa Halaby (Queen Noor of Jordan). (MPA.)

Eric Hall Dorsey
Eric Dorsey's father, Lawrence L. Dorsey, was a policeman in the District who was killed in the line of duty when Eric was three. His mother, Sue, raised both Eric and his brother, Kyle, as a single parent. Eric attended McLean High School, where he was a standout on the football team at several positions. He set records in the discus and shot put and excelled on the wrestling team. After graduating, Dorsey continued with football at Notre Dame University, playing defensive end. In 1986, he was drafted by Bill Parcells for the New York Giants. He played defensive lineman (1986–1992), earning two Super Bowl rings, until his career ended after hip-replacement surgery. He now coaches young players at Testsports Club and supports the IES Brain Research Foundation Charity. (Sue Dorsey.)

Edwin Lawless III "Barney" Lawless attended Western High School and hitchhiked to get there, often getting a ride with Bernie Boston or Sam Redmond. He was active with Boy Scout Troop 128 and continued with the troop as an adult, serving 23 years as a scoutmaster. This 1966 photograph shows Barney with Tim Van Epp (right) and Bob Goode (left), who were receiving their Eagle Scout medals. (Barney Lawless.)

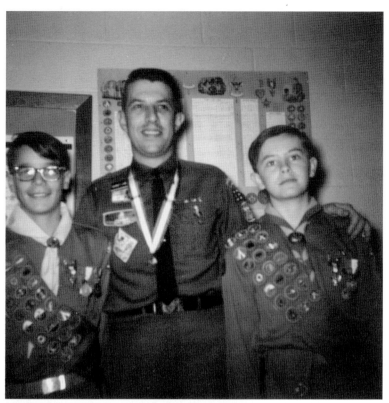

Stan Richards A past president of the McLean Rotary Club and McLean Orchestra, Richards served on McLean Community Center's governing board and Friends of the McLean Community Center, where he headed the effort for a balcony in Alden Theatre. His company, The Richards Corporation, donated a fiber artwork to hang at the MCC. Richards is shown here with Gail Nields at a MCC event. (McLean Community Center.)

Frances Kenney Moore
Moore, granddaughter of William Sanford Sharper, a founder of Pleasant Grove Church, was among the organizers of Friends of Pleasant Grove, formed in 1982 to save and preserve the church. After she died, her children donated ancestral items from her home to open a museum in the lower level of the church. Moore is shown outside the church during a community fair. (Wanda Collins and Sonja Carter.)

Michelle Spady
Spady, a former teacher of English and computer technology, is a past president of the National Coalition of 100 Black Women and is presently Eastern Area Program Chair for The Links, Inc. Until recently, she owned and operated Simply Sparetime, an afterschool program for youth at the Shiloh Baptist Church. With her son Bradford, she formed B'Artful, a company that promotes emerging artists and writers. (Michelle Spady.)

Peggy Fox

Fox, a graduate of Virginia Tech, is a three-time Emmy Award winner as a journalist at WUSA-9. She has been the emcee at Alden Theatre events and McLean's Reindog and Winterfest Parades. Since 2006, she has been the Girl Scout leader of Troop 698. Fox is shown here after a Reindog Parade with daughter Leah (left) holding her dog Brownie, and Ben and Lizzy Mennitt, holding their dog Noire. (Peggy Fox.)

Paul Shiffman

Shiffman, a lawyer with Shiffman & Shiffman, PC, attended the University of Virginia and, after graduation, attended the American University School of Law. He is passionate about sports, particularly baseball. Shiffman was president of McLean Little League in 1981 and, starting in 1967, he has continuously managed a McLean Little League team. Paul (right) is shown with a former McLean player, Cam Hester. (McLean Little League.)

Robert Ames Alden

Bob Alden was the driving force that led to McLean establishing a civic and cultural center complex that today consists of a community center, theater, library, and central park. The park was dedicated in 1966, the library in 1967, and the McLean Community Center, with theater, in 1975. Here, Alden (left) poses with Dan and Karen DuVal at their Salona home. (McLean Project for the Arts.)

Merrily Pierce

A voice for citizen issues throughout Fairfax County, Pierce was president of McLean Citizens Association (1995–1997) and Fairfax County Federation of Citizens Associations (1998), and first chair of Fairfax County's Citizen Corps Council (2003–2005). She served as legislative aide for two chairs of the Fairfax County Board of Supervisors, Audrey Moore (1987–1991) and Kate Hanley (1998–2003). In addition, Pierce was transportation aide for Supervisor Cathy Hudgins (2006–2010). (John Pierce.)

Zeynel Abidin Uzun
Uzun grew up in Istanbul, where he became interested in the culinary arts. He was the chef for President Fahri Koruturk while serving in the Turkish military. After arriving in America, he continued his professional culinary skills as chef for Royal Caribbean Cruise operating out of Miami. Uzun later opened Nizam Restaurant in Vienna, which was followed by Kazan Restaurant in McLean in 1980. (Carole Herrick.)

Vito Pappano
Pappano moved to McLean to help his uncle operate his dry cleaning business, Enrico's, which was established in 1956 in the not-yet-completed Salona Village Shopping Center. In 1958, the center was finished, and Enrico's relocated into a larger space, where it is today. Vito Pappano enjoys baseball, often attending games of the Washington Nationals. He has sponsored a McLean Little League team for many years. (Carole Herrick.)

Peter G. Fitzgerald

Sen. Peter Fitzgerald, his wife, Nina, and son Jake lived in McLean during the years Peter represented Illinois in the US Senate (1999–2005). After retiring, McLean became their permanent residence. Fitzgerald, along with four McLean businessmen, opened Chain Bridge Bank in 2007. The five founders are, from left to right, Jerry Fitzgerald, Philip "Chico" Herrick, Peter Fitzgerald (chairman), Thomas Jacobi, and Paul Shiffman. (Carole Herrick.)

Omer Lee Hirst

A descendent of George Mason, Hirst was in the real-estate business. He served in Virginia's House of Delegates (1954–1959) and Virginia's Senate (1964–1979). As a legislator, he opposed "Massive Resistance" and worked to establish George Mason University in Fairfax. He was instrumental in creating the Dulles Toll Road. Officially, the road is named the Omer L. Hirst–Adelarol Brault Expressway. (George Mason University.)

Mike Cannon
Mike has managed McLean Hardware since 1982. At that time, the store was located on Old Dominion Drive, but it moved to its present location on Chain Bridge Road in 2008. McLean Hardware provides necessary items for the community, including lawn and garden supplies. Standing here, from left to right, are Colin, Mike, and Cyndee Cannon in the Weber Grill showroom. (McLean Hardware.)

George Kapetanakis
In 1969, Kapetanakis and two relatives, Pete Sampras Sr. and George Vroustouris, began operating a delicatessen in the Salona Shopping Center, at the former location of Herman's Deli. This continued until 1979, when Kapetanakis became the sole proprietor and changed the delicatessen operation into the McLean Family Restaurant, which served American food along with some Greek cuisine. (Carole Herrick.)

Tom Liljenquist
Tom is the cofounder and president of Liljenquist & Beckstead Jewelers. Along with his sons, Jason, Brandon, and Christian, he collects rare portrait photographs of Civil War soldiers, which he then donates to the Library of Congress. Its collection of 1,200 images has put a human face on a war that killed more Americans than all other US wars combined. (Erin Kilday.)

David Graling
A practicing CPA, Graling received both his bachelor's and master's degrees from George Mason University. In 1980, while attending school, he was president of the McLean Volunteer Fire Department, and, from 1993 to 1994, he became president of the McLean Citizens Association. His wife, Paula, is a clinical nurse specialist at Inova Fairfax Hospital. Posing here are, from left to right, Ted Gray, David Graling, Bill Byrnes, and Lilla Richards. (Merrily Pierce.)

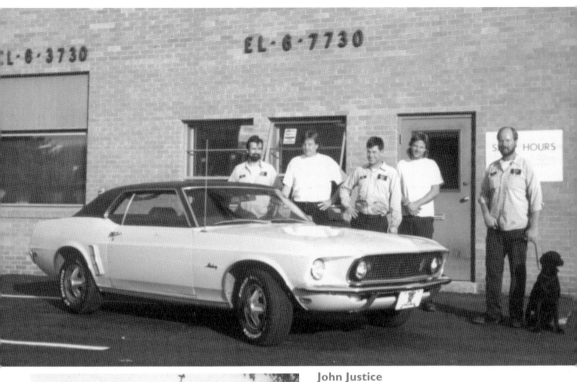

John Justice

After returning home from service in the Marine Corps in 1970, Justice began working for his father, Paul, at the McLean Service Center on Chain Bridge Road. He took over the business after his father's death in 1975 and semiretired in 2010. His brother James then began operating the business. Standing here are, from left to right, Vince Stidham, John Justice, Jeff Cash, James Justice, Wayne Turner, and Hercules. (John Justice.)

Joan Marie Parker

Parker had a heart for animals and cared for the innocent creatures with a great deal of pleasure. She was known as the Dr. Doolittle of McLean. She devoted much of her time and energy to giving all kinds of injured animals another chance at life by rescuing them, nurturing them back to health, and then setting them free. (Zoe Sollenberger.)

125

INDEX

INDEX

Find more books like this at
www.legendarylocals.com

Discover more local and regional history books at
www.arcadiapublishing.com

Consistent with our mission to preserve history on a local level, this book was printed in South Carolina on American-made paper and manufactured entirely in the United States. Products carrying the accredited Forest Stewardship Council (FSC) label are printed on 100 percent FSC-certified paper.